Dedicated to Trina, Miya, Aila, Mom, Grandpa, Dad, Nana, Chous, all
my family, friends and everybody I've shot photos of.

Special thanks to SLAP, the Vitello family, Joe Brook, Randy Dodson,
Craig Stecyk, Nate Denver, Matt Hathaway, Dave Rosenberg, TMA,
David Lopes, Cleon Peterson, all the photographers and artists I have
been inspired by, and skateboarding.

Cover Image: Tommy Guerrero, San Francisco, 2006

First Published in the
United States of America, 2009

First Edition
Gingko Press, Inc.
1321 Fifth Street
Berkeley, CA 94710, USA
Phone (510) 898 1195 / F (510) 898 1196
email: books@gingkopress.com
www.gingkopress.com

ISBN: 978-1-58423-360-2
Printed in China
All photographs by Mark Whiteley
© 2009 Mark Whiteley
Design by Cleon Peterson with Zach Gibson
All Rights Reserved.

THIS IS NOT A
PHOTO OPPORTUNITY

MARK WHITELEY

GINGKO PRESS

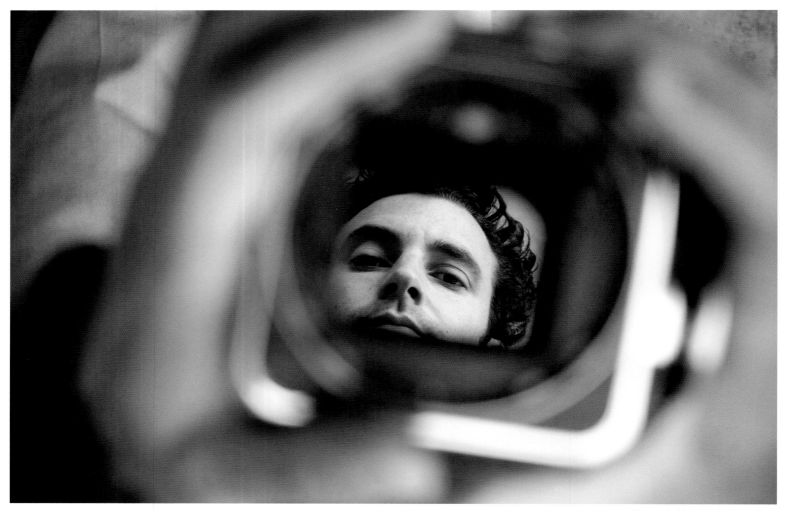

MARK WHITELEY, SAN FRANCISCO, 2009

THIS IS NOT A PHOTO OPORTUNITY

— Craig Stecyk

Whereas. "Bureau Chief, Keyboard Wrestler, Shutter Tripper, Curb Cut Carver." The man has already chiseled out his own epitaph in concrete, silver halide and digibytes. Mark Alexander Whiteley was born during the American bicentennial and raised in the Bay Area 'burb of Los Altos. This background was a sure-fire prescription for art school incarceration just down the El Camino Real at the University of California at Santa Cruz-UCSC being the same august institution where they honed the Chaos Theory, contemporaneously to his term of enrollment. Team mascot: Sammy the Slug. All hail the blue and gold! Fiat Lux.

An ardent skateboarder, Whiteley found the bedrock of his artistic direction in his transport and recreational choices. His forte was a participatory variation of the traditional recording of the social landscape. Initiated types demanded he expand his horizons. Phil Shao was a top pro skater who graduated with honors from Berkeley only to then tragically perish in a car accident; Paul Zuanich was another paramount rider who investigated ferret ranching before being sucked into the vortex of a Stanford Research fellowship. Those two outstanding individualists believed in the relevance of Mark's work and took him over to SLAP magazine to meet its publisher Fausto A. Vitello and founding editor Lance Dawes. While the university aesthetic mentors had encouraged Whiteley towards a certain homogenous thematic consistency in his work, the kingpins of High Speed Productions not only endorsed his instinctive stylistic diversity, they offered him employment.

Whiteley jumped on board the editorial staff and evolved his way up to the head staff position. SLAP has always enjoyed a reputation for being the most sublime of the skate publications. It's content was notable for a delicate blend of art, music, culture and hardcore riding. The title also was remarkable for not being controlled by a large publishing conglomerate, as were almost all its competitors in the skate/surf/culture genre. Under his guidance SLAP's prominent newsstand presence was boldly shed, in favor of exclusively pursuing free and rapid dissemination of information on the Internet. Purveyor/curator/conspirator of a cyberspace wunderkammer portal. He's blogged for years. Dispatches: About gothic bikini snake charmers. Cupping tippy golden first flush teas. Collegiate railings with good transition planes. Aesthetics. Loading docks. Political discourse. Sewer contours. Women of poetry. Song.

An axilotl named Zooch looks down from his terrarium at the atelier's worktable. Some shelf or another has a Leica M6 on it. A Hasselblad rests in another nook; next to it there is a digital Leica. Another box containing a Canon EOS system is abandoned over there. Mark's point is that it is not about equipment. Rather he's versatile in his approach using any combination of machinery to achieve a slightly stylized documentation.

This to me is a catalogue raissone stripped bare to the bones. Mark is a noted archivist of architects of dissent, and the petit-metiers captured by Whiteley are oftentimes the only evidence of unique acts that will never be repeated. His subjects include both the fabulously celebrated and the arcanely anonymous. Whiteley's portraits are studies in anti-heroics. His repertoire of tilts, shifts, stereoscopic works, pointilistic grain, electronic flash techniques, invisible radiation spectrum films, ortholithographic negatives, serigraphic imagery, mismatched aspect ratios, split focus planes and torqued panoramics all are employed in the service of documentation. His knowledge and mastery of a wide variety of photographic media and image gathering devices is amply demonstrated in his oeuvre. But they are used solely to augment the situational language of the subjects, never as excessive pyrotechnics. The understatements he creates are successful and immediately identifiable to viewers as sophisticated graphic statements. Their codified aspects remain cloistered within the tight society which created them and to those with the need to know and the gumption to find out.

What motivates a man who deconstructed an established magazine into a web–based phenom to return to stoic book publishing? Why exhume Gutenberg's carcass for a new autopsy? Dead and gone is all the way past and has no chance in the here and now. The answer, like most of this presenter's doings is more provocation. Whiteley "values books as beautiful objects more so than as seeing them as superior vehicles for imparting knowledge." A physical collection of photographs sewn or glued together and bound between flexible covers is locked into time in a way that web-based media isn't. So in your hands, rests the weight of Mark Whiteley's current premise. A document for the ages rendered from miscreantic wanderings.

PORTRAITS

SCOTT BOURNE, SAN FRANCISCO, 2001

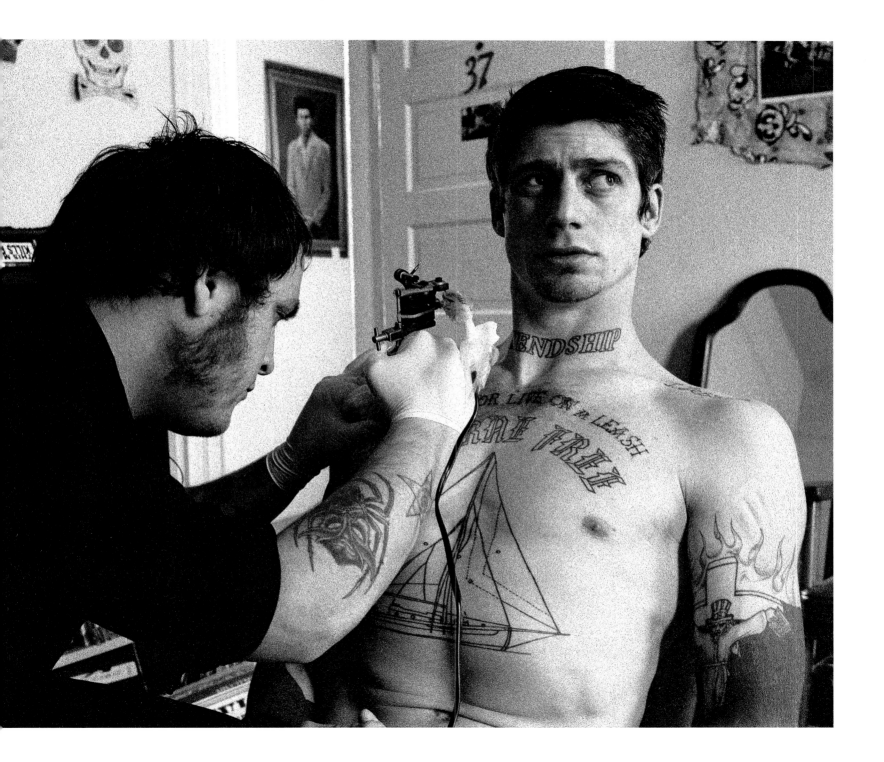

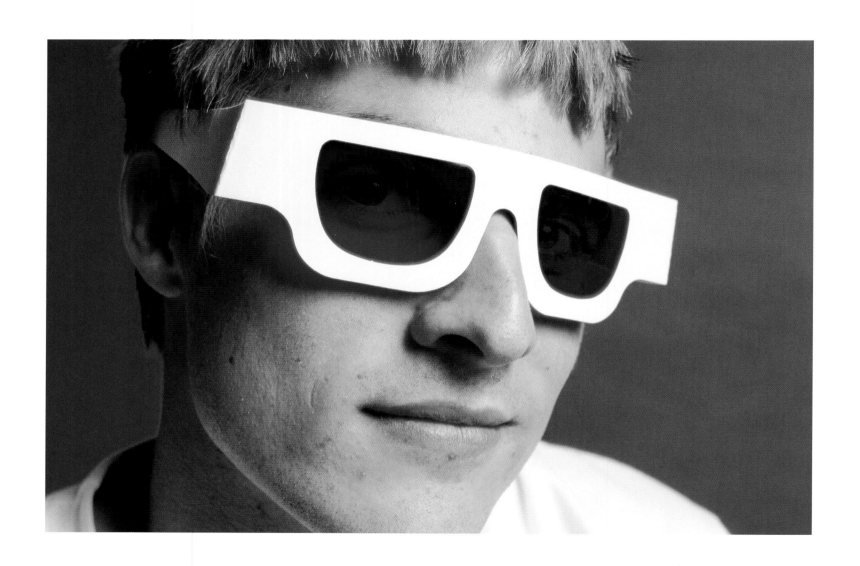

JON EHINGER, SAN FRANCISCO , 1999
JAMIE THOMAS , SAN FRANCISCO , 2001

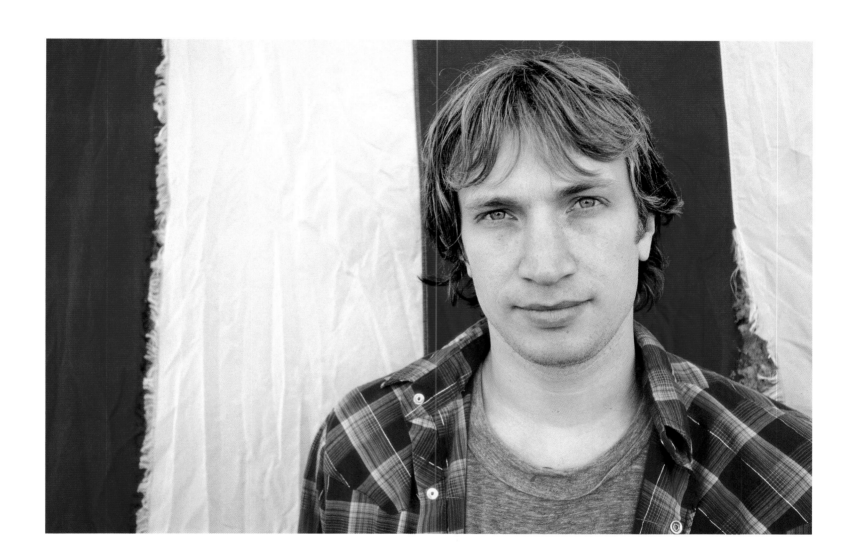

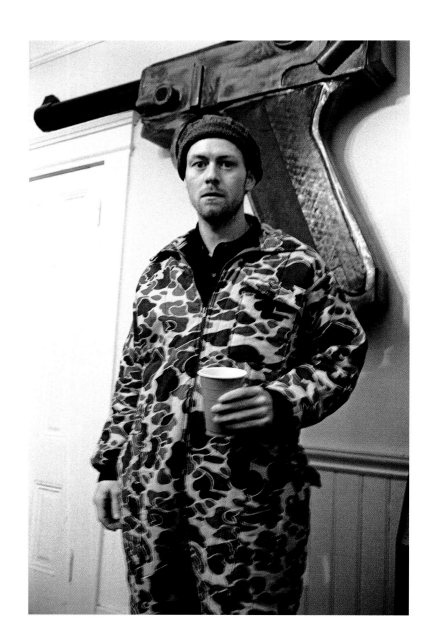

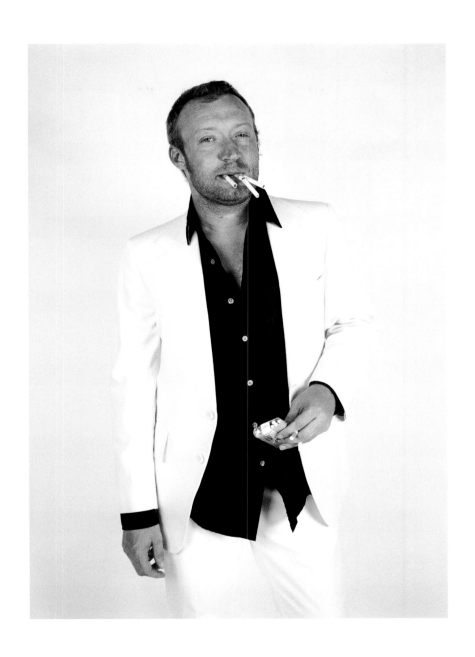

MARC JOHNSON , SAN JOSE , 2003
DAN DREHOBL , SAN FRANCISCO , 2005

MATT HATHAWAY & JASON ADAMS, HAYWARD CA, 2005

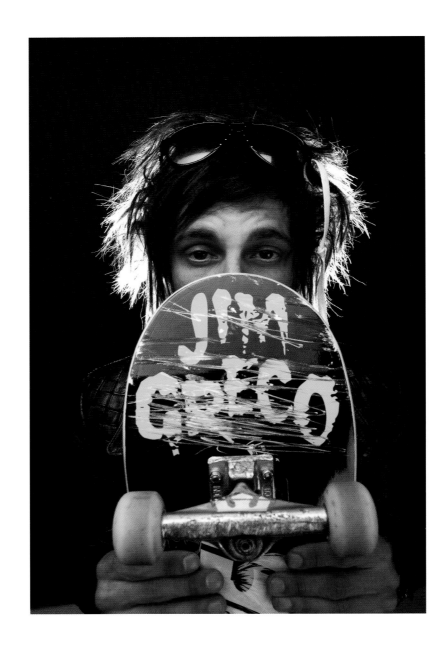

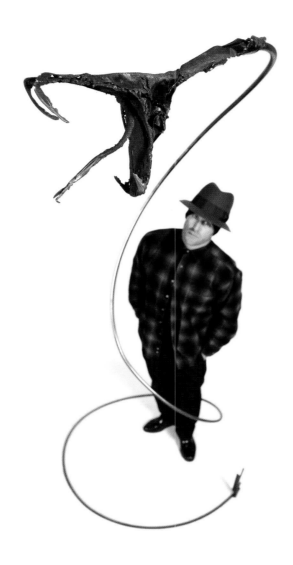

JIM GREEO, SAN FRANCISCO, 2007
JASON JESSEE, WATSONVILLE CA, 2007

TONY COX, SAN FRANCISCO, 1999
JESSE ERICKSON, MILPITAS CA, 2003

THOMAS CAMPBELL, MARIN CA, 2006

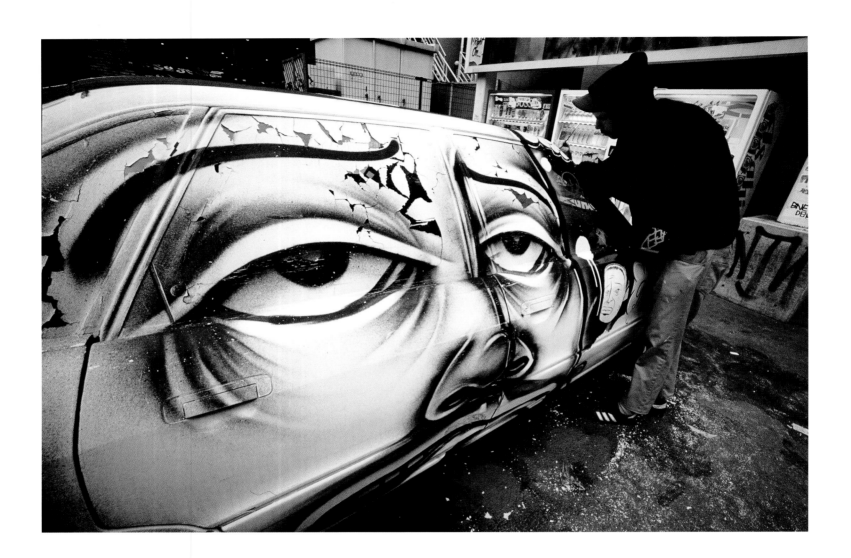

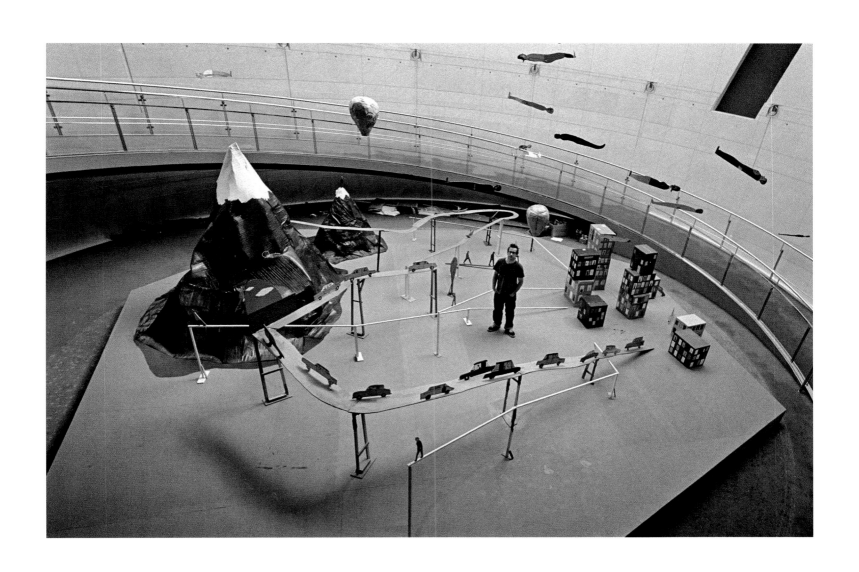

BARRY McGEE , TOKYO , 2001
CHRIS JOHANSON , TOKYO , 2001

JEREMY FISH, SAN FRANCISCO, 2008, 2007

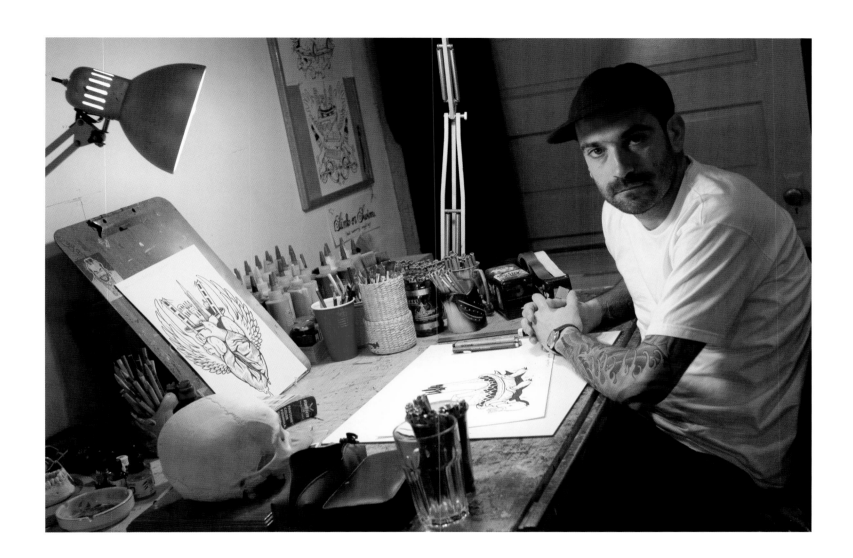

SELF PORTRAIT , CAIRO FOSTER , PALO ALTO , 2006

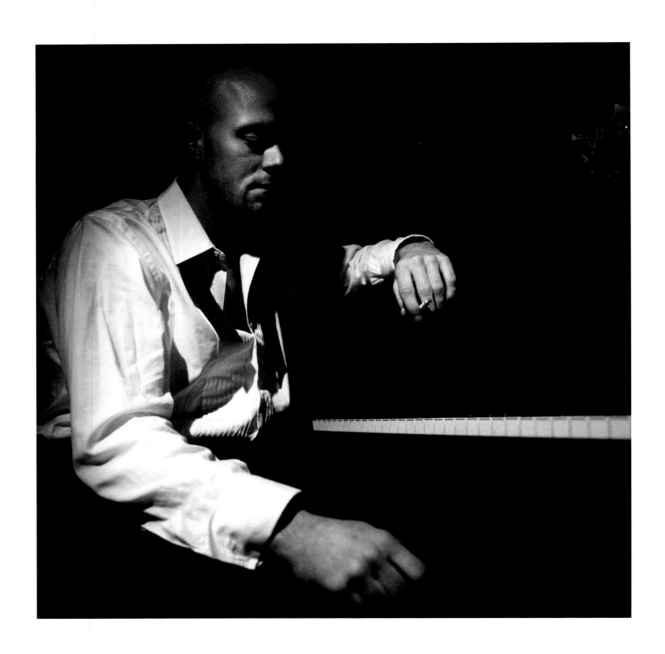

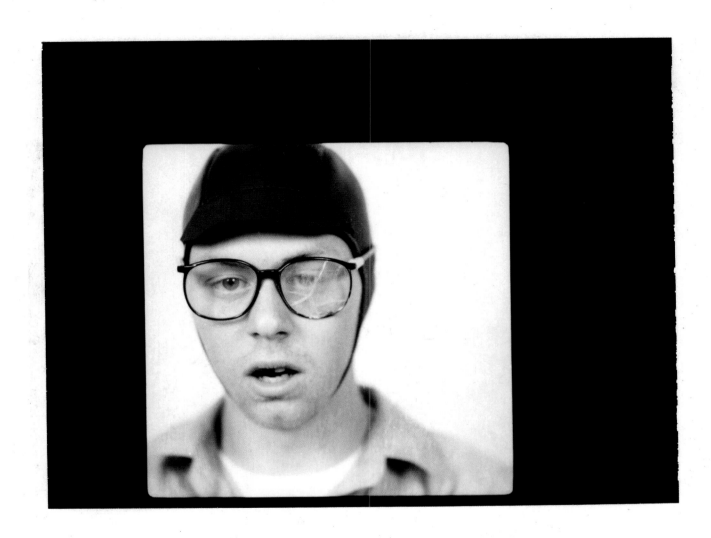

MARC JOHNSON, LOS ALTOS CA, 2002
MARC JOHNSON, SUNNYVALE CA, 1998

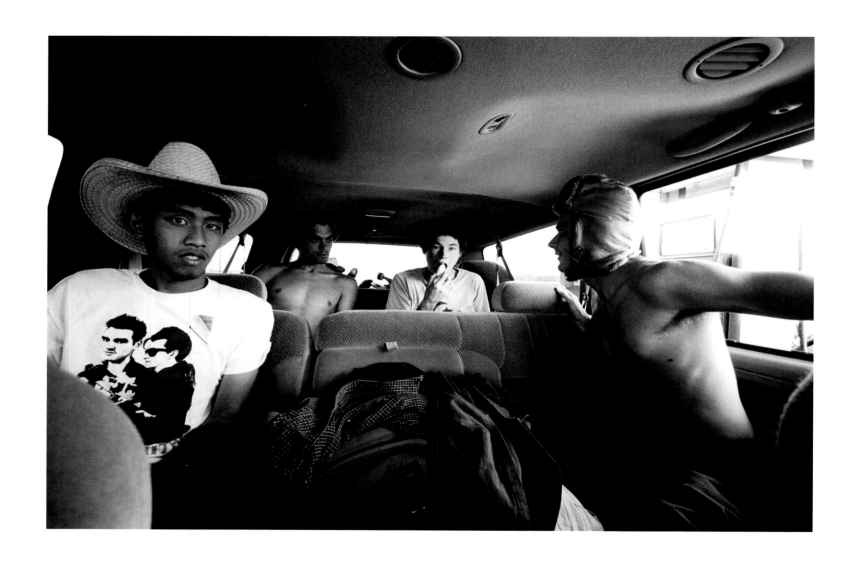

JERRY HSU, JUDD HERTZLER MIKE RUSCZYK
TONY COX, FAIRBANKS AK, 2000
PHIL SHAO , PALO ALTO , 1997

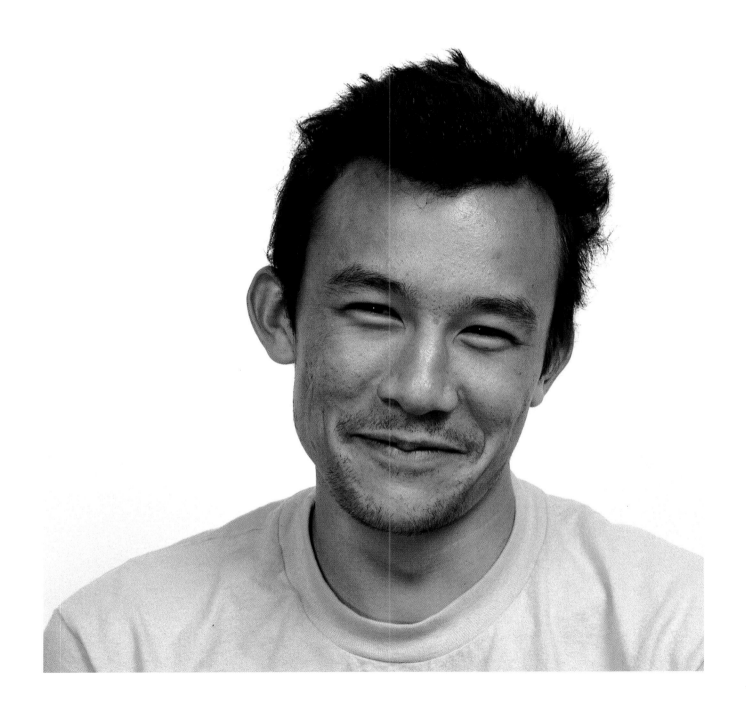

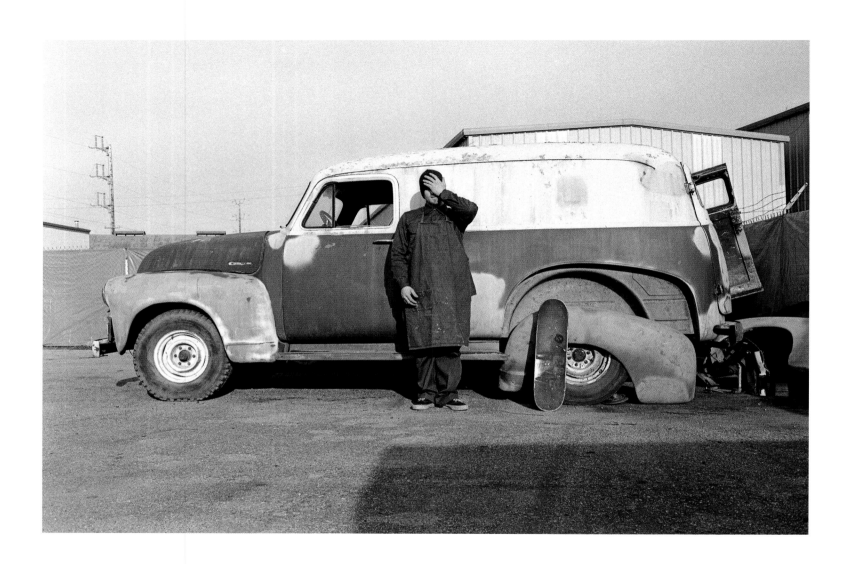

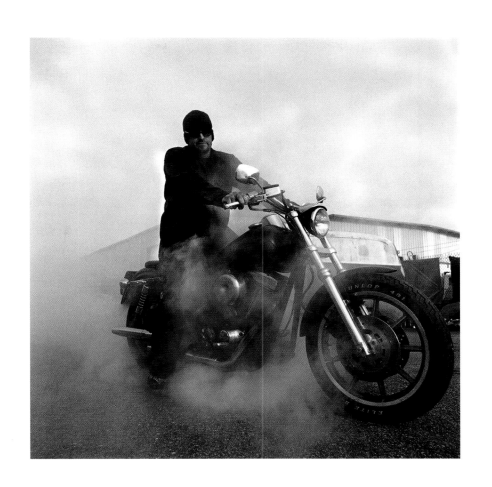

JASON JESSEE, WATSONVILLE CA, 2002

CRAIG STECYK, LANCE MOUNTAIN, LOS ANGELES, 2009

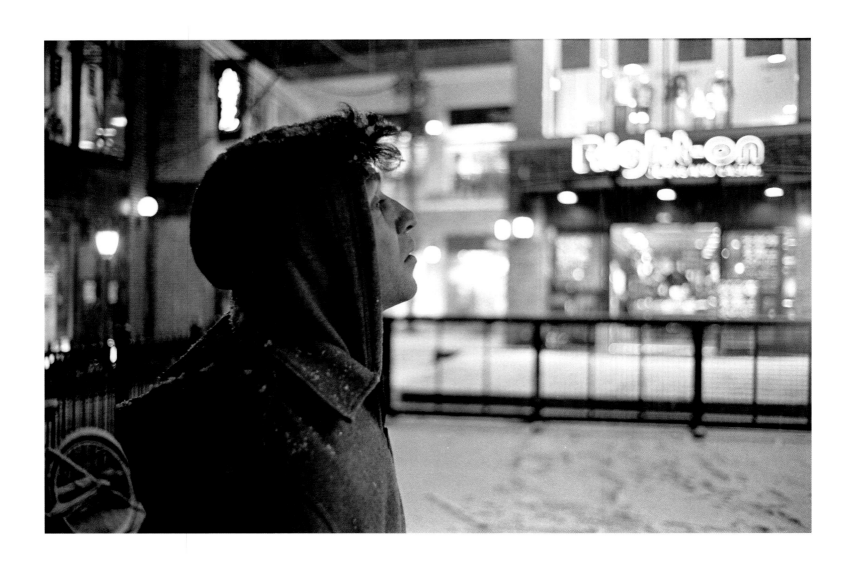

MARK GONZALES , TOKYO , 2001
LOUIE BARLETTA , SAN JOSE , 2007

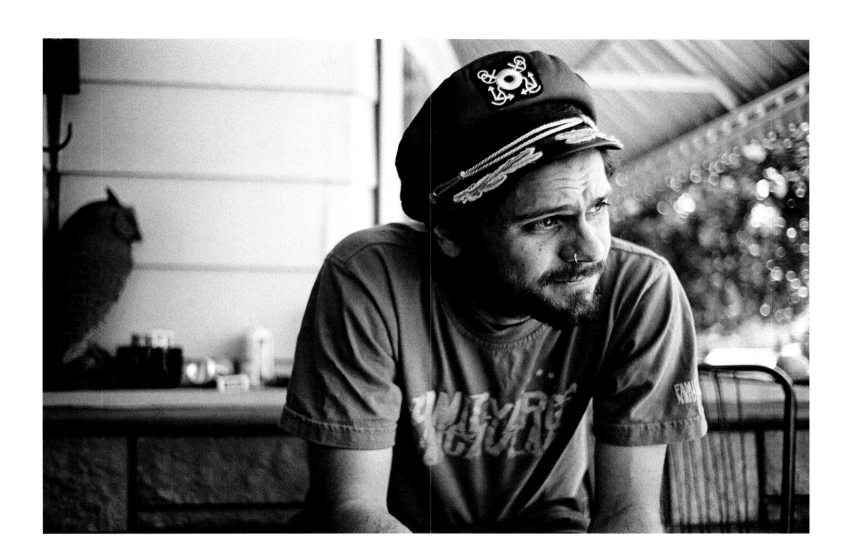

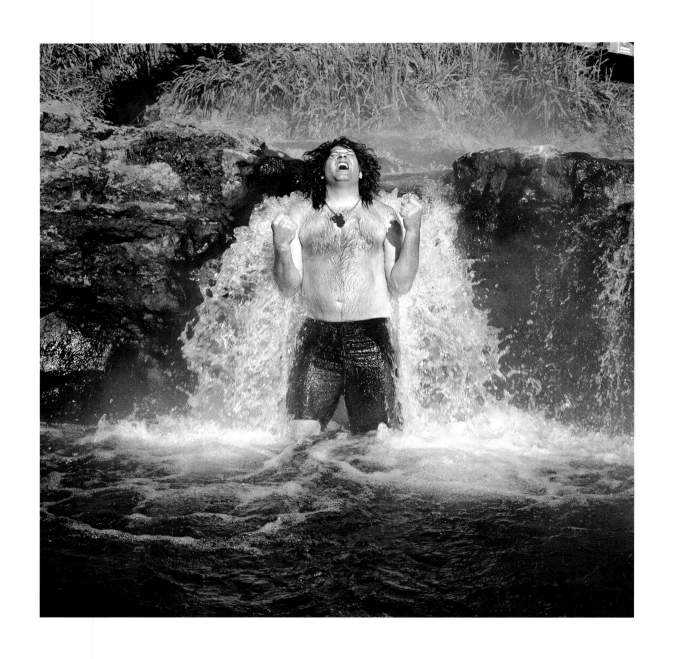

DAVE DUNCAN, TAUPO, NEW ZEALAND, 2003
HUNTER MURAIRA, HONG KONG, 2005

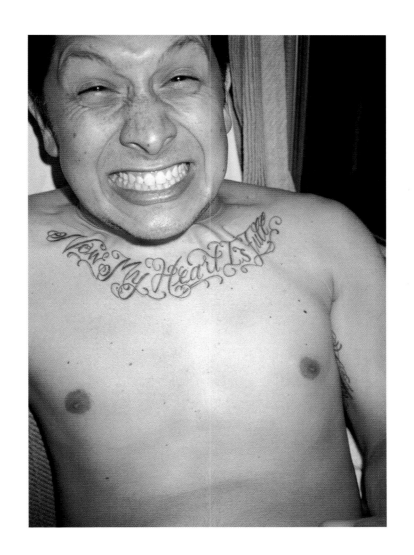

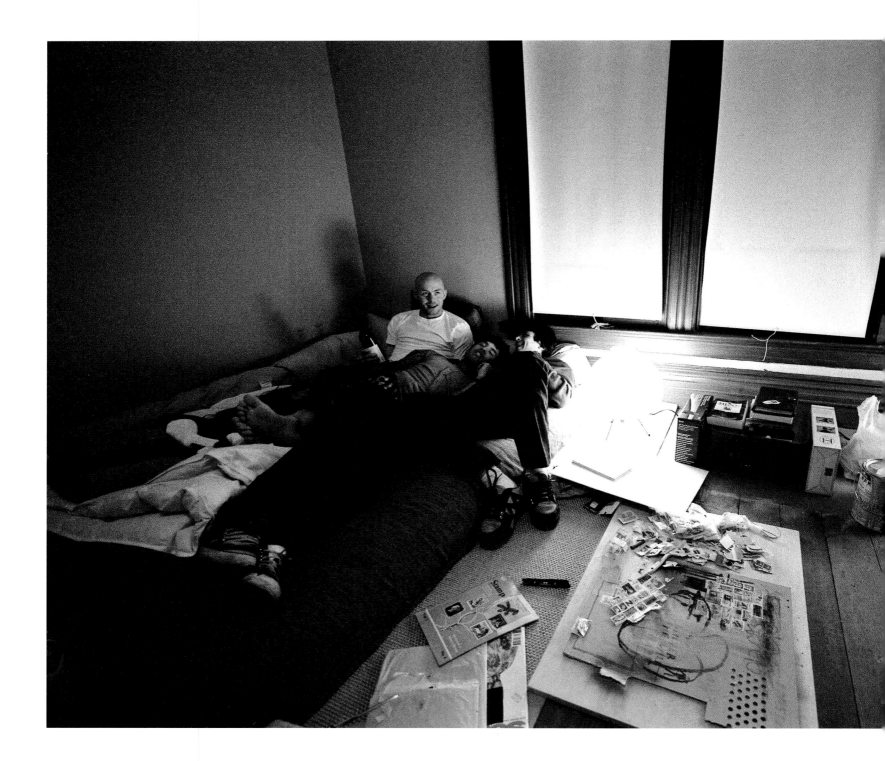

MARC JOHNSON, JERRY HSU, LOUIE BARLETTA. SAN JOSE, 2002

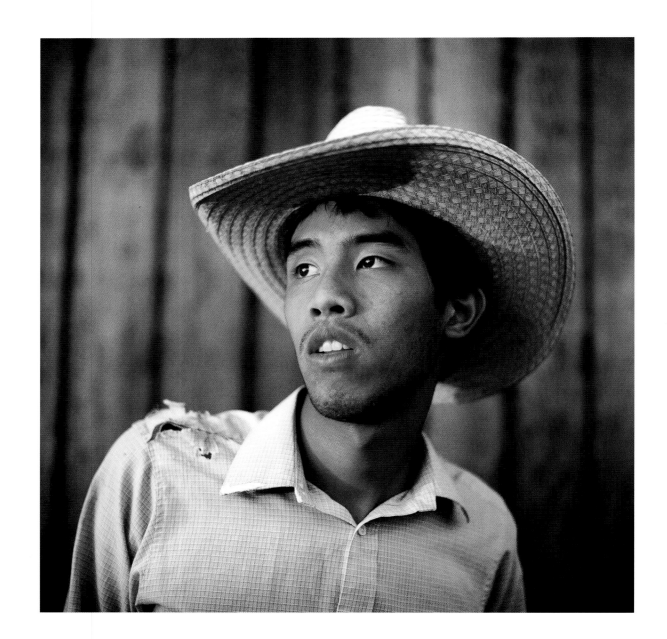

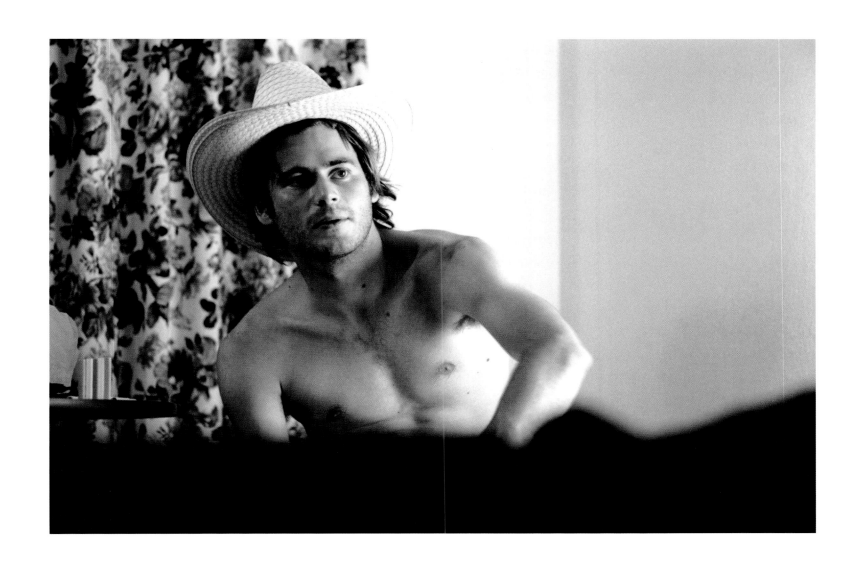

JERRY HSU, TONY COX, FAIRBANKS AK, 2000

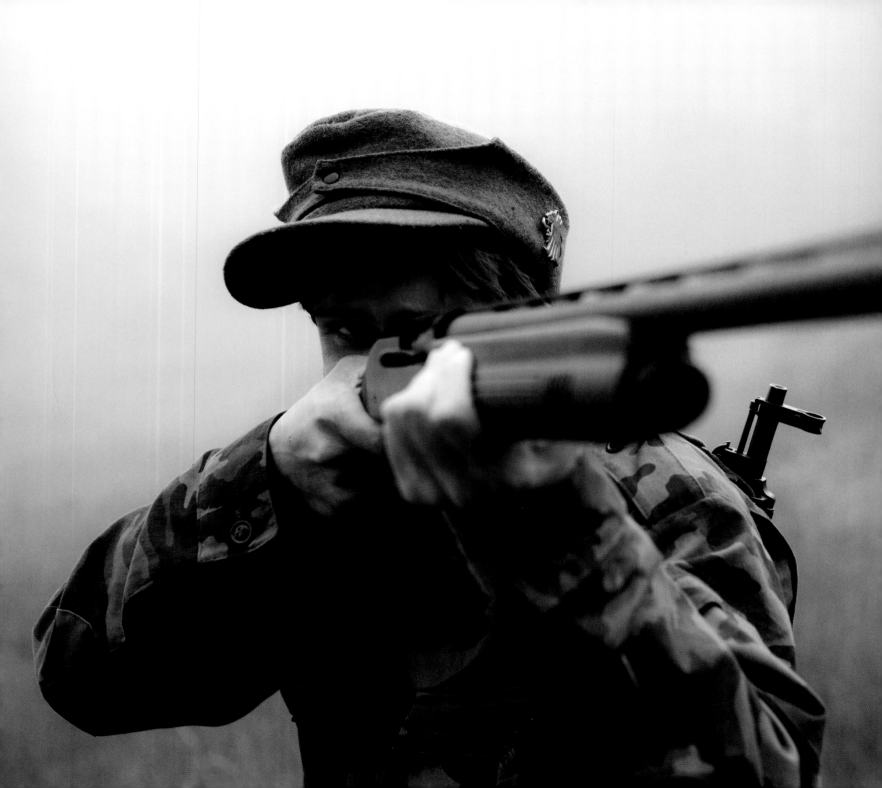

LOUIE BARLETTA, NAPA CA, 2006

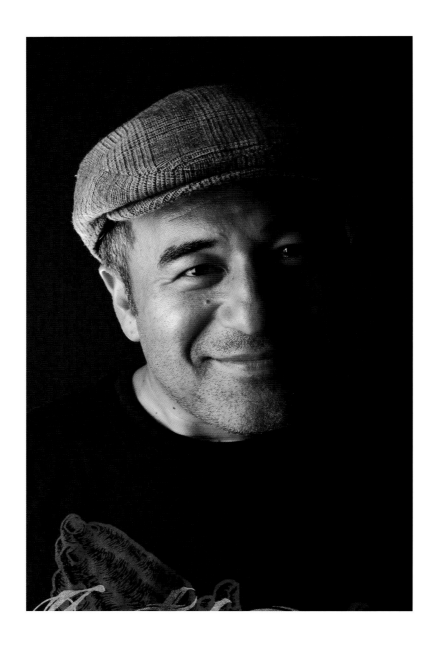

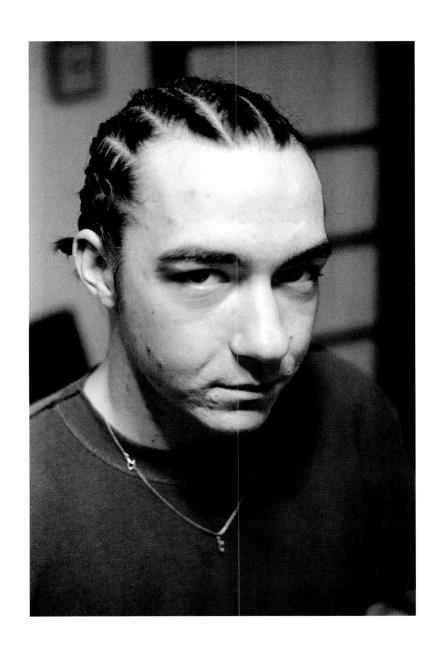

STEVE CABALLERO, SAN FRANCISCO, 2006
CASWELL BERRY, KAILUA HI, 2003

MATT FIELD , MARIN CA , 2007

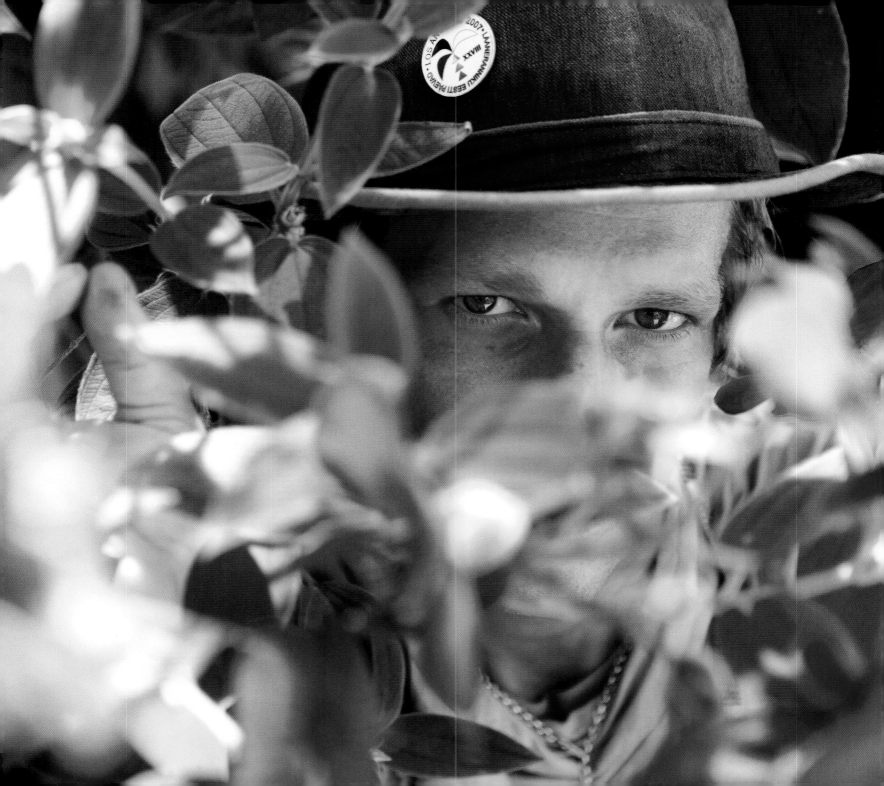

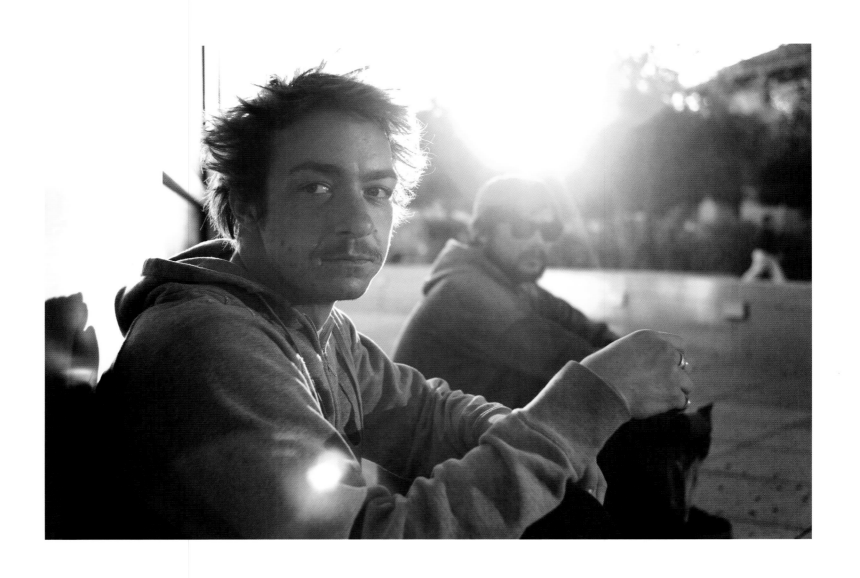

CASWELL BERRY , PALO ALTO , 2007
JASON JESSEE , WATSONVILLE CA , 2008

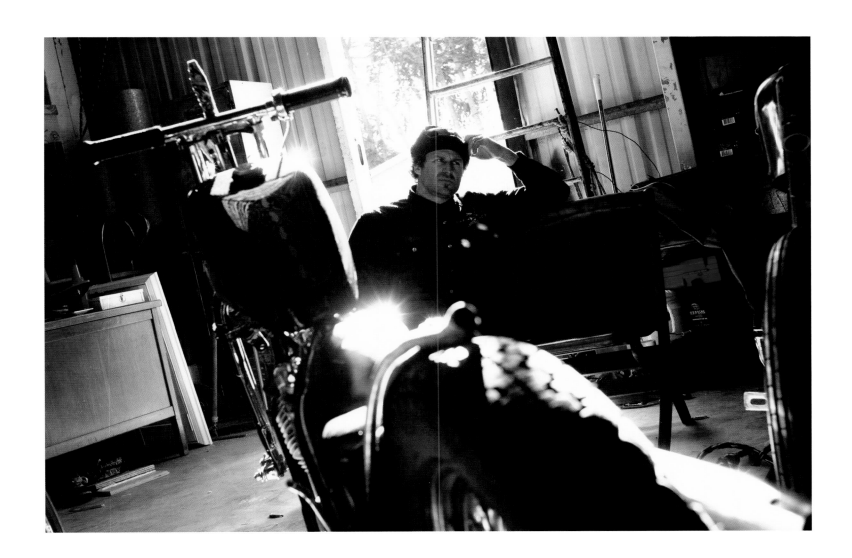

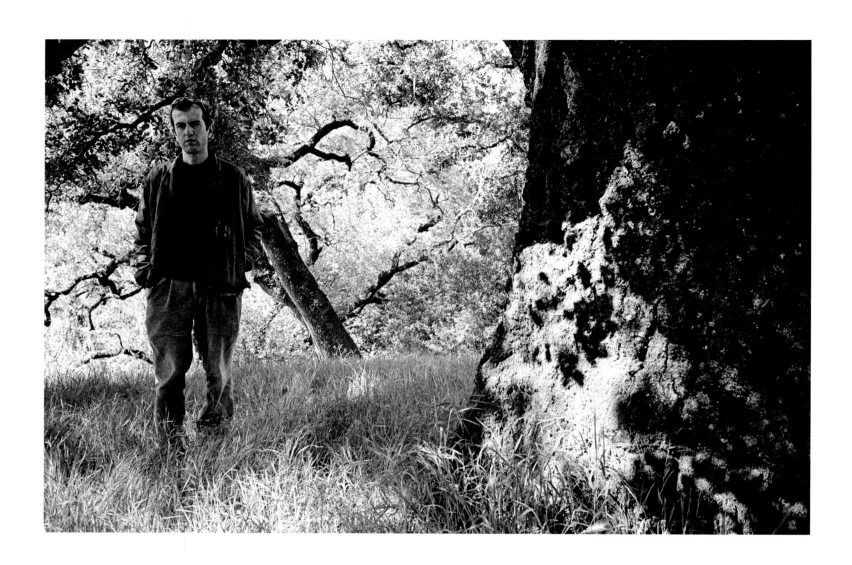

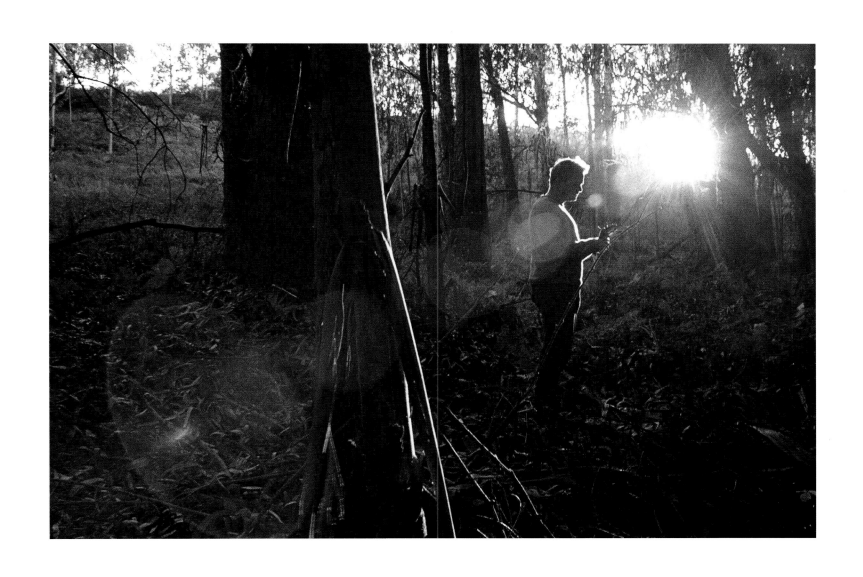

ARI MARCOPOULOS, SONOMA CA, 2001
THOMAS CAMPBELL, MARIN CA, 2006

STREET, TRAVEL, & SNAPS

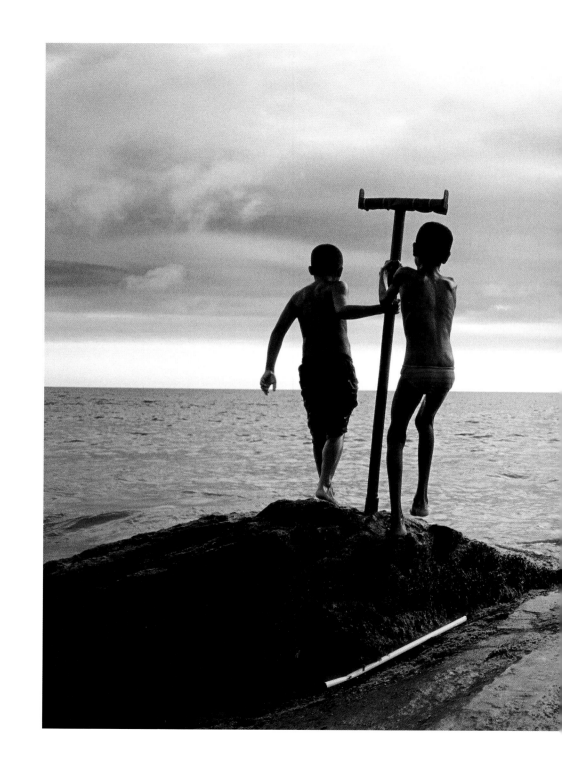

KIDS , RIO DE JANEIRO , 2002

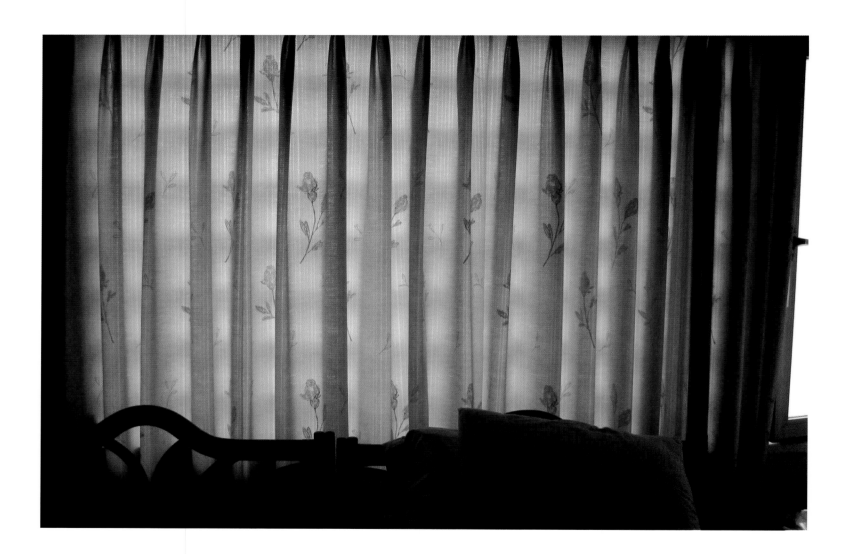

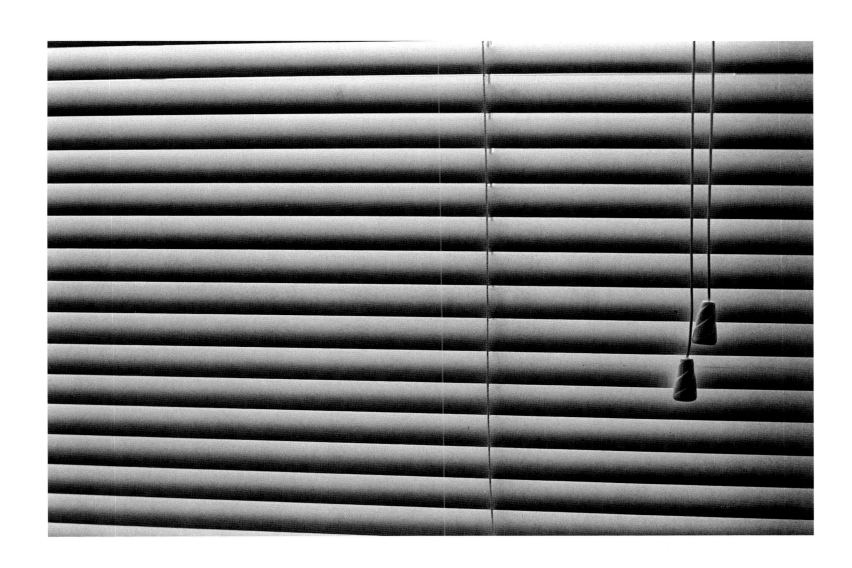

CURTAINS, TOKYO, 2006
BLINDS, PALO ALTO, 2004

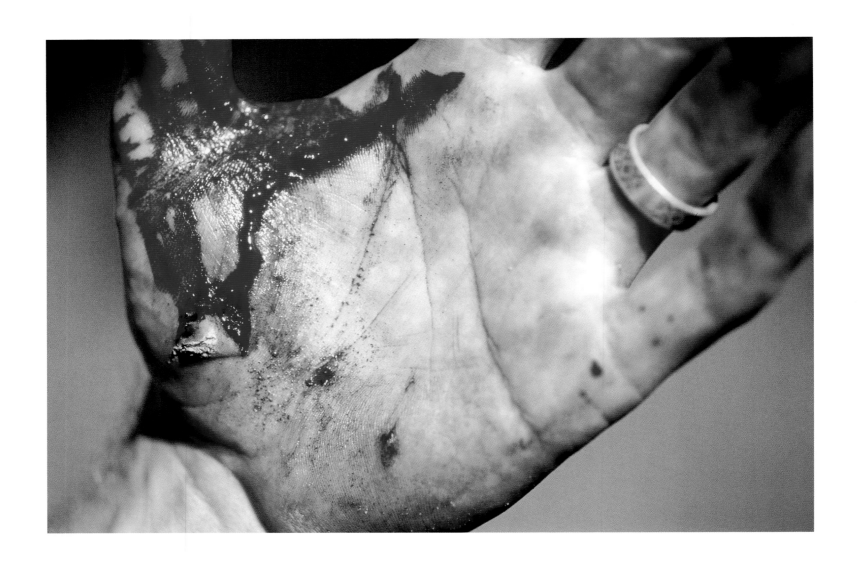

MIKE'S HAND, SUNNYVALE CA, 2003
CHERRY BLOSSOMS, TOKYO, 2008

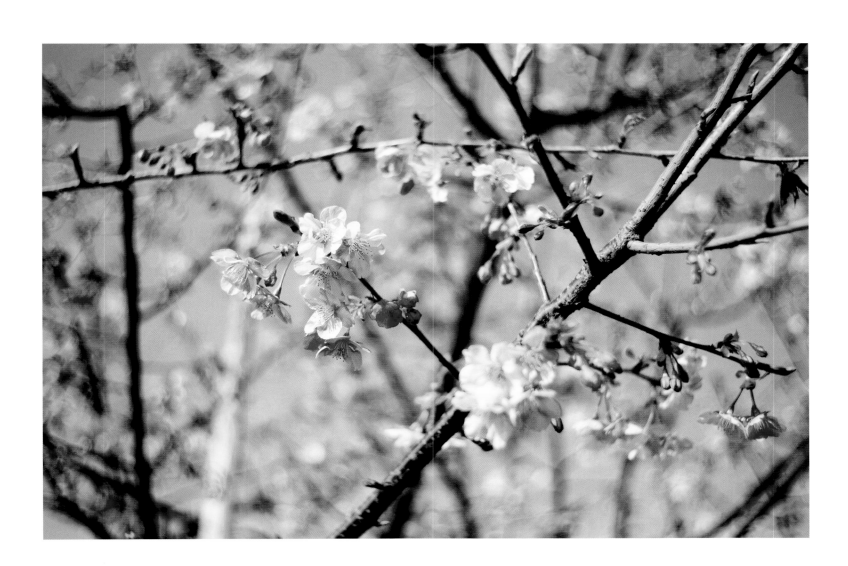

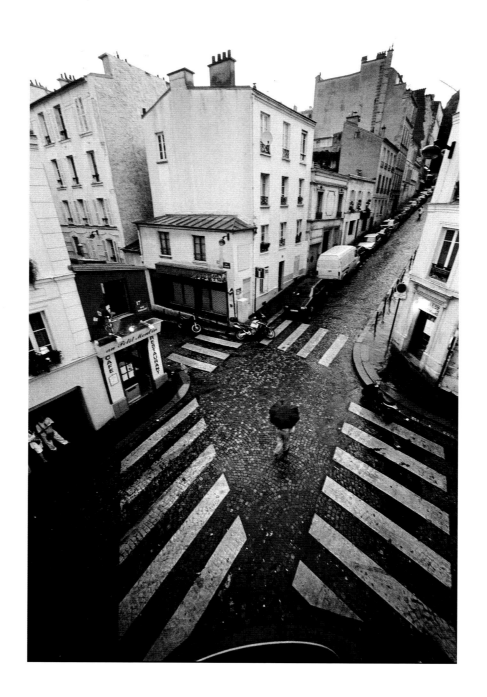

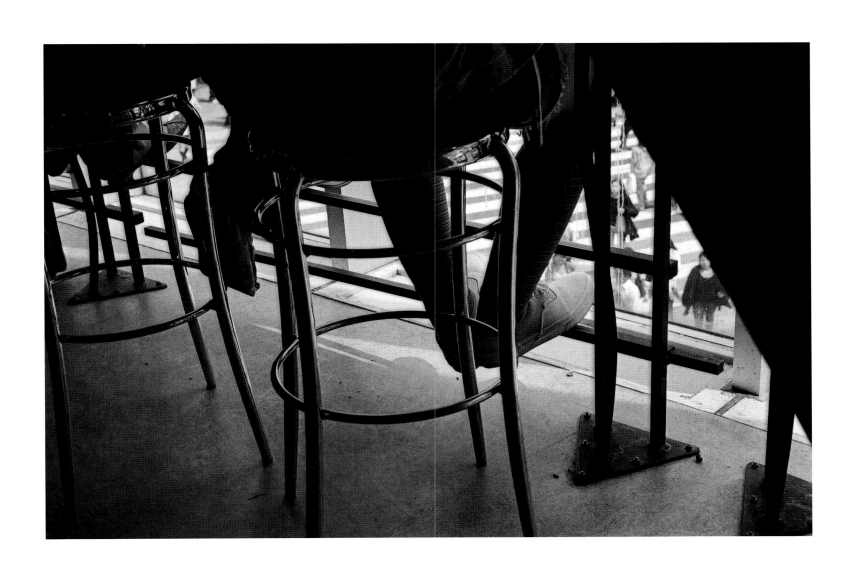

CROSSWALK IN PARIS, 2001
CROSSWALK IN TOKYO, 2004

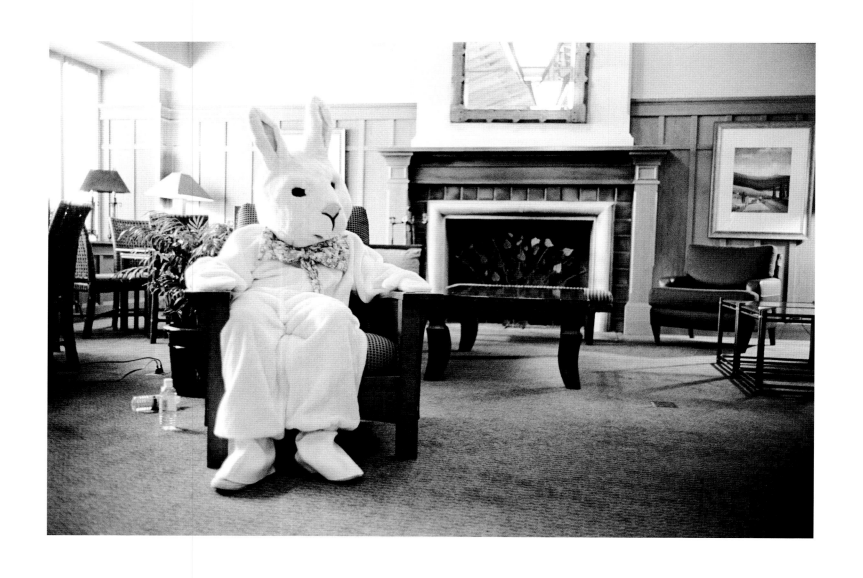

EASTER BUNNY ON BREAK, LOS ALTOS CA, 2007
GIRL WITH ZEBRA MASK, NEW YORK CITY, 2007

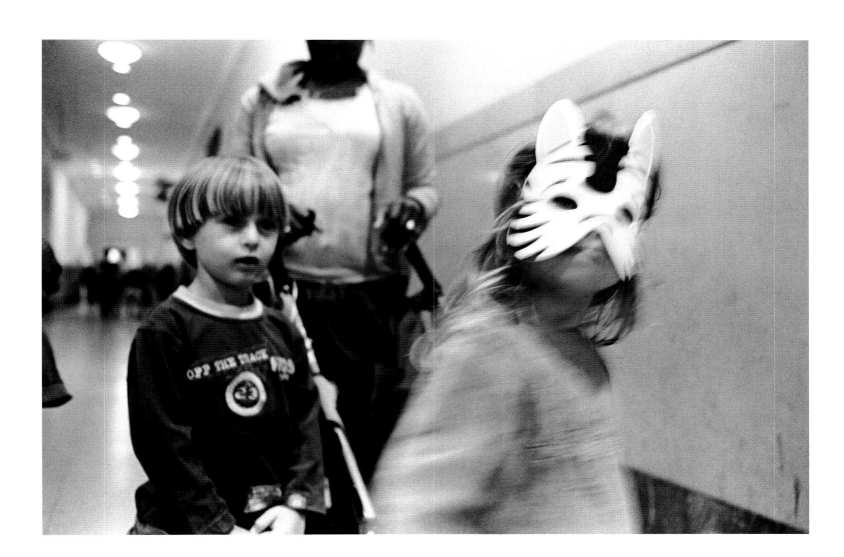

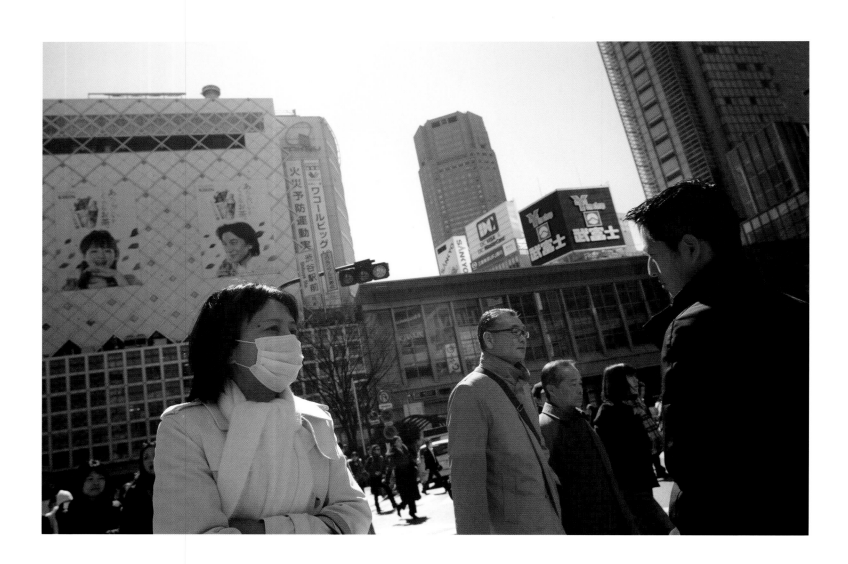

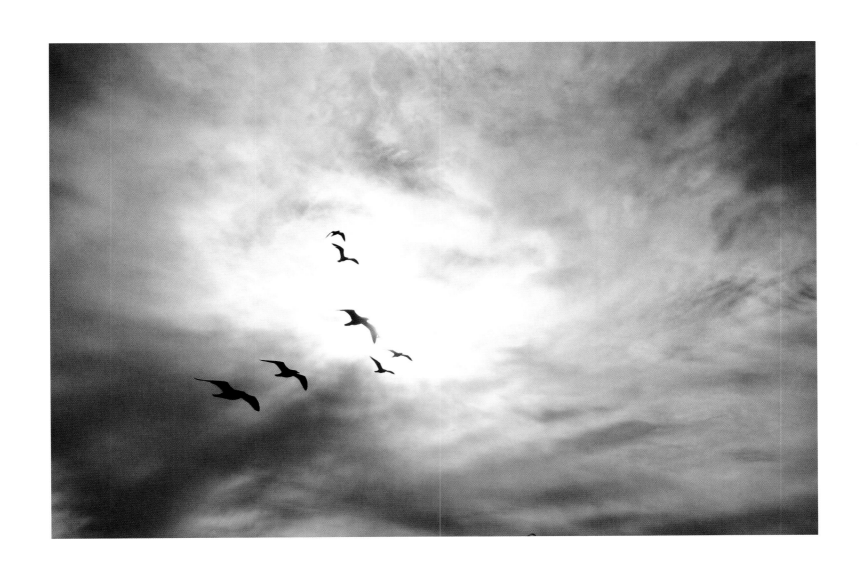

SHIBUYA STATION CROSSWALK, TOKYO , 2008
SEAGULLS , PESCADERO CA , 2005

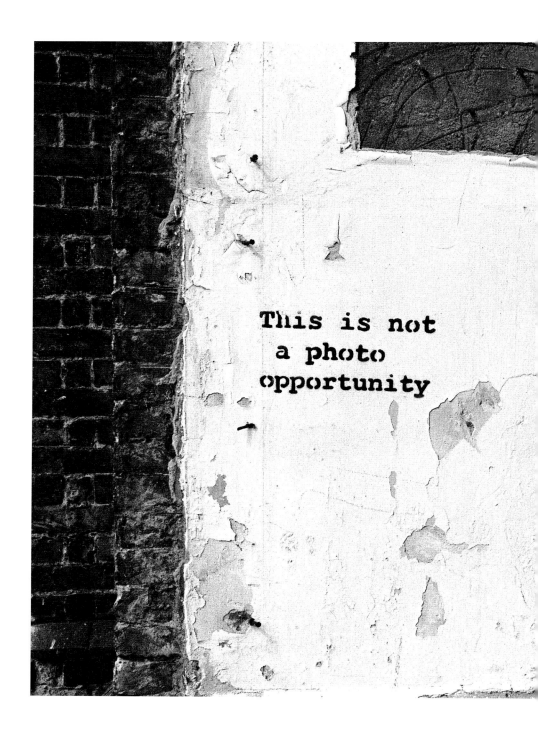

BANKSY WAS HERE, LONDON, 2001

UNDER THE TRAIN , PALO ALTO , 1997

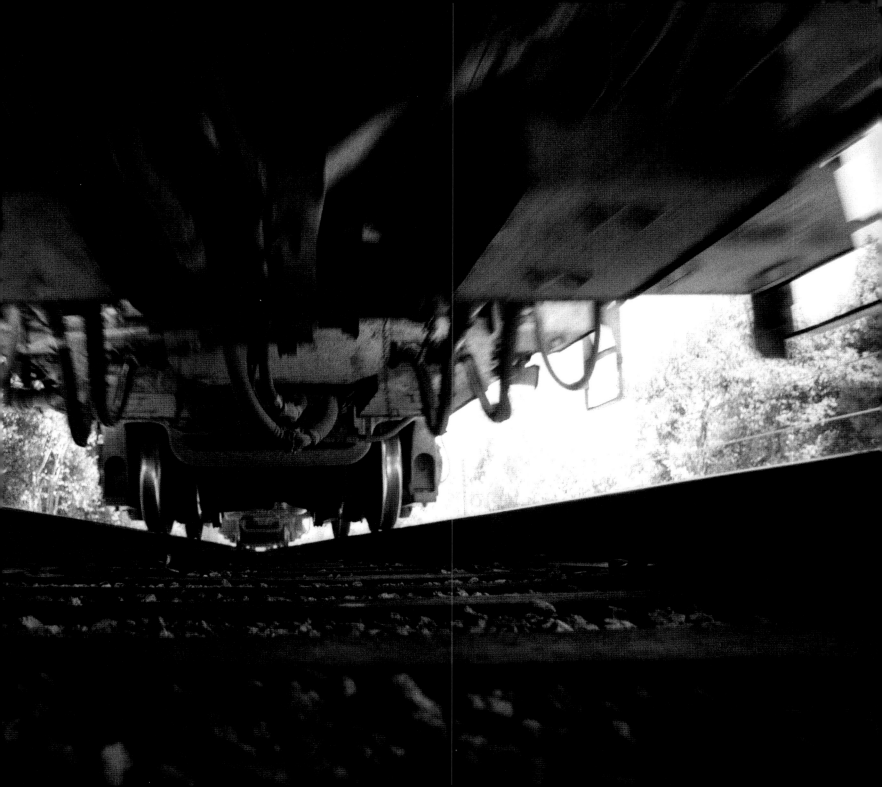

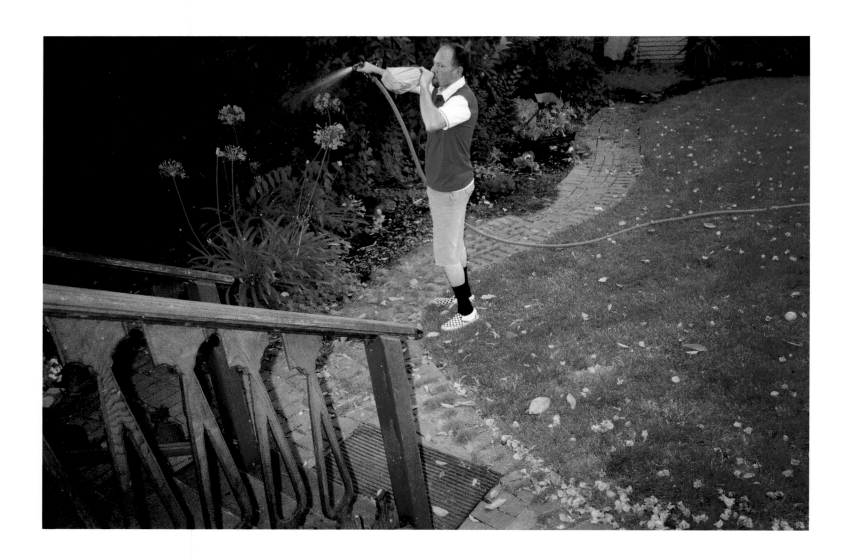

BROWN BAG LAWN CARE, SAN JOSE, 2004
STEEP MOWING, PORTRUSH, N. IRELAND, 2001

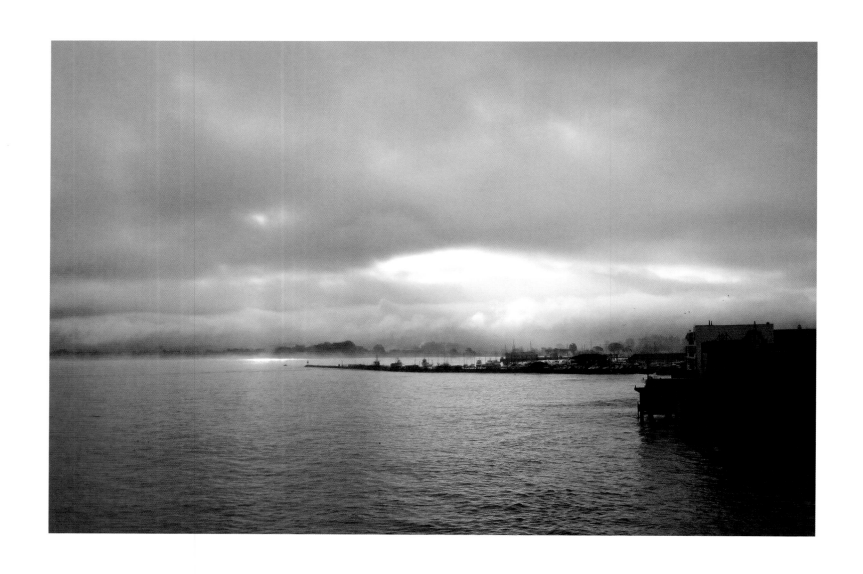

WHARF, MONTEREY CA, 2006
SUNSET FROM A PLANE, 2006

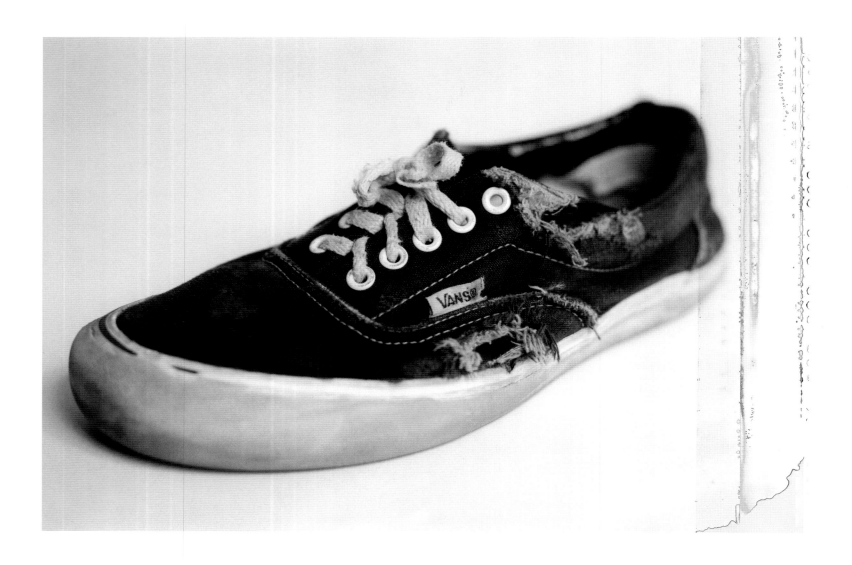

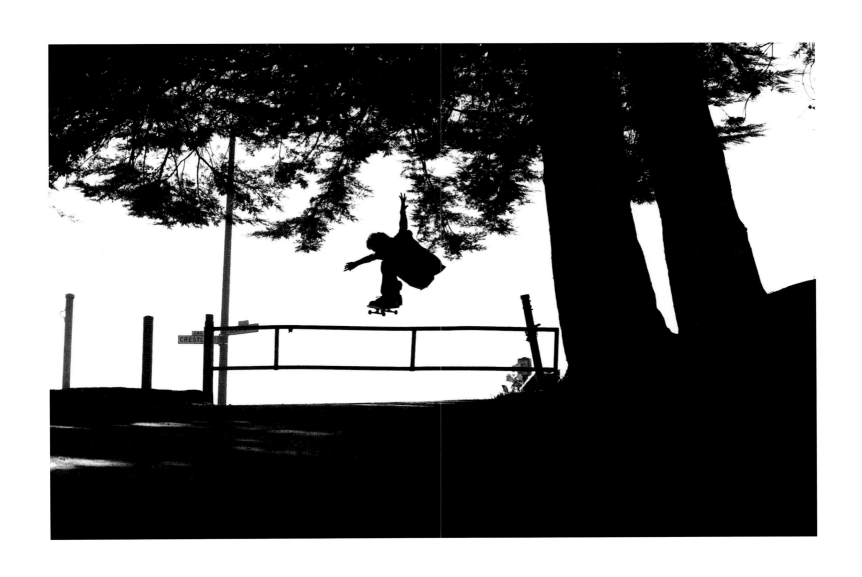

WELL-SKATED SHOE, 1999
MATT FIELD, OLLIE IN S.F., 2000

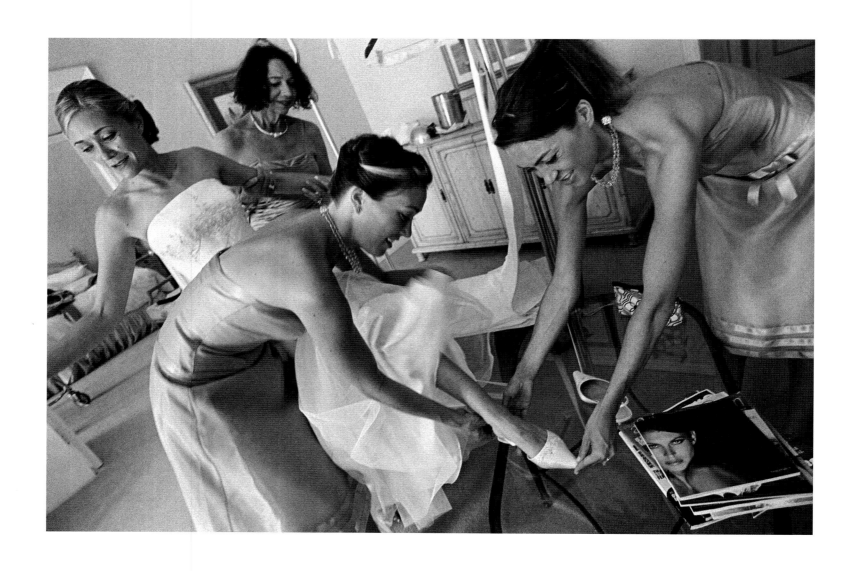

KATIE VAN THILLO, SISTERS & MOM, PREPARING FOR WEDDING, KAPAWA HI, 2006
CLARE DAWSON & BRIDESMAIDS, PREPARING FOR WEDDING, COSTA MESA CA, 2002

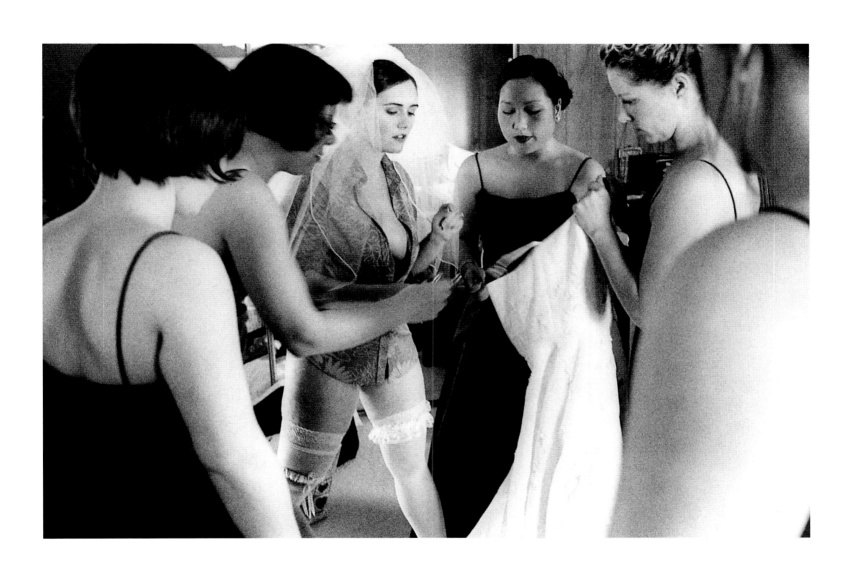

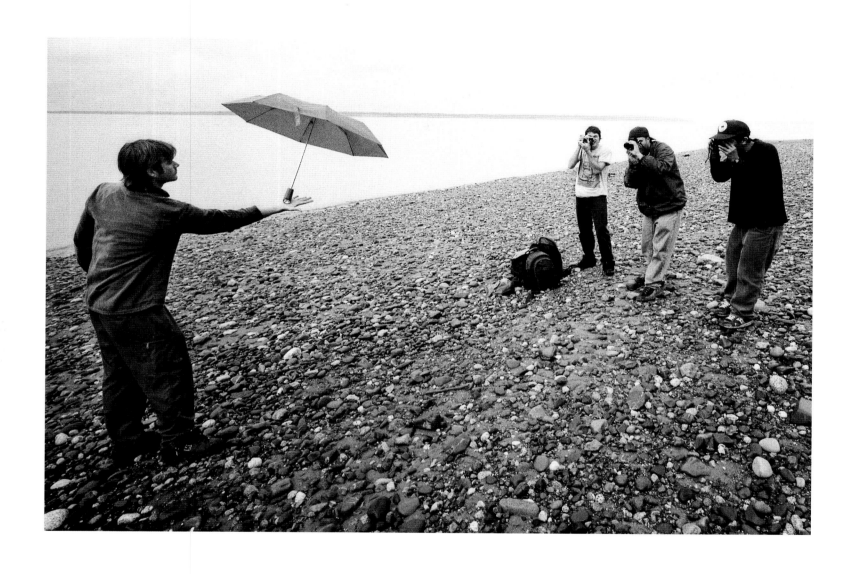

TONY COX , MIKE RUSCZYK , JOE BROOK , JERRY HSU , ANCHORAGE AK , 2000
LAST DAY AT THE PINK HOUSE , SAN JOSE , 2004

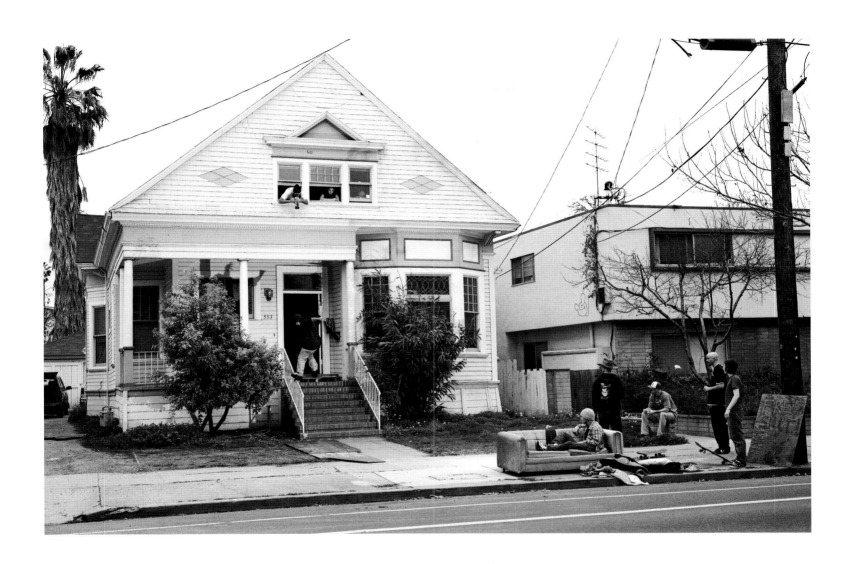

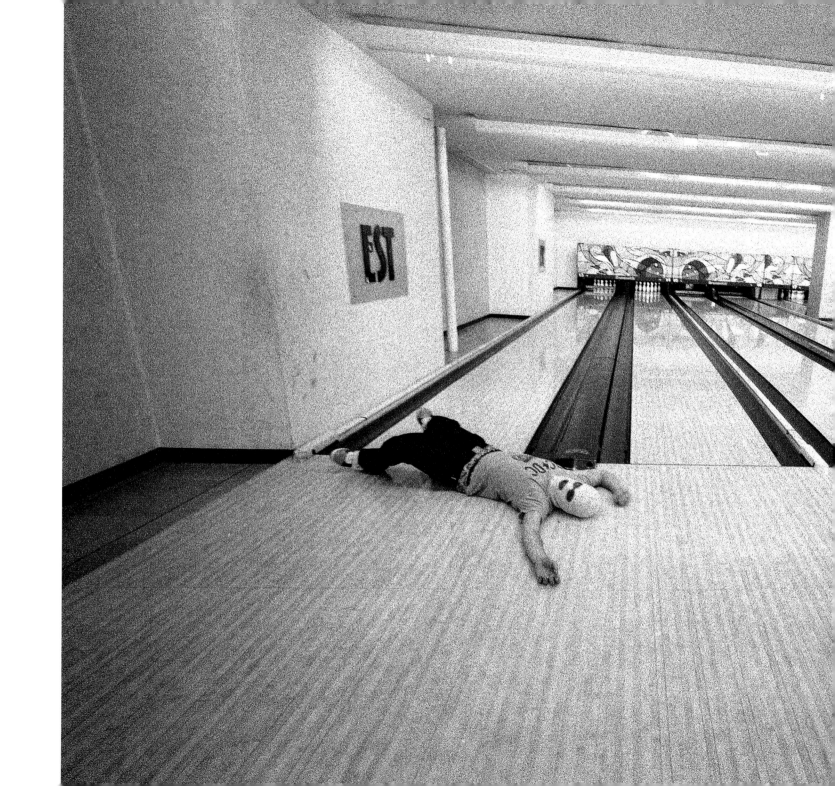

TONY TRUJILLO , TOKYO , 2001

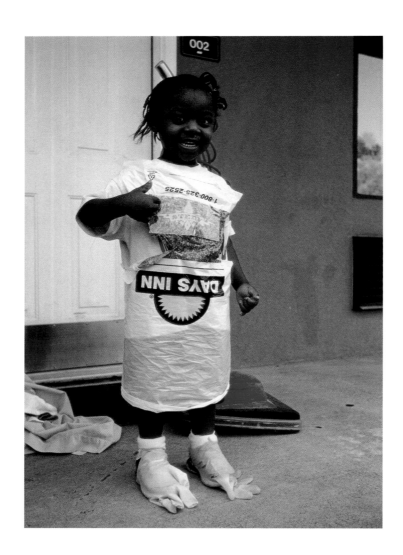

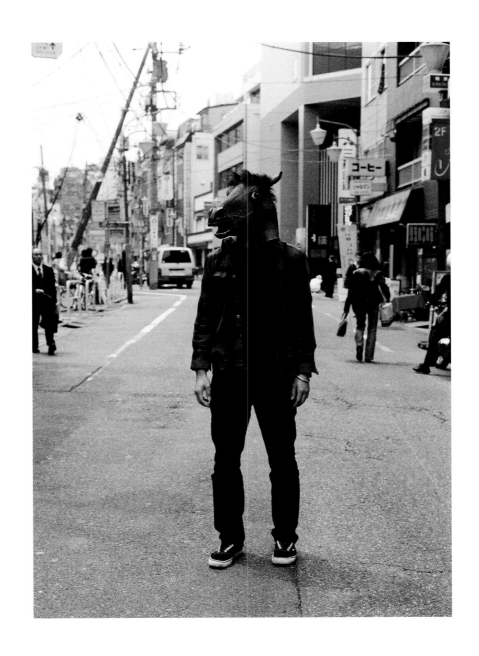

MAID'S DAUGHTER, MEMPHIS TN, 2002
JERRY HSU, TOKYO, 2006

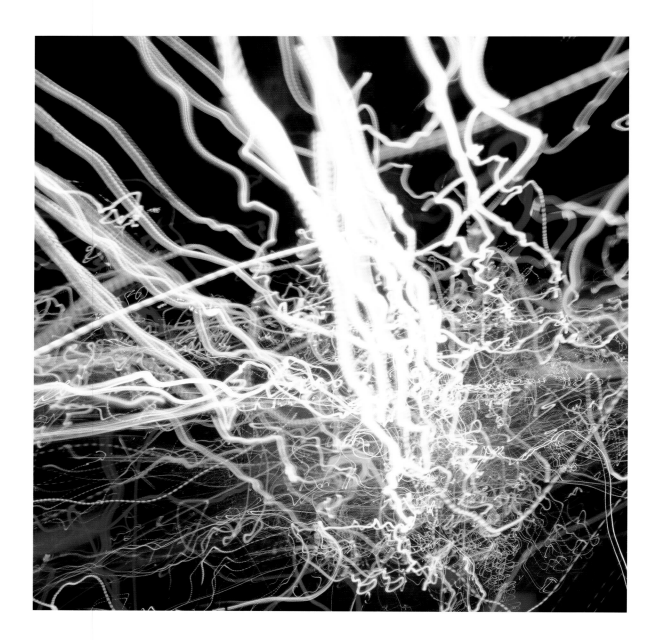

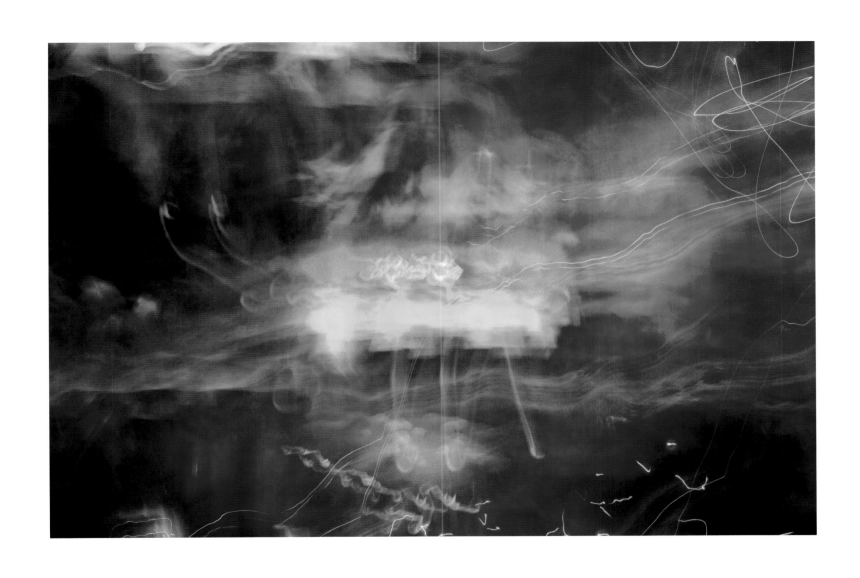

LONG EXPOSURE WHILE DRIVING, LOS ALTOS CA , 1997
LONG EXPOSURE ON THE "SMALL WORLD" RIDE, DISNEYLAND, 2007

PINK SHOES, TOKYO, 2008
SPOTS OF RED IN THE SNOW, TOKYO, 2001

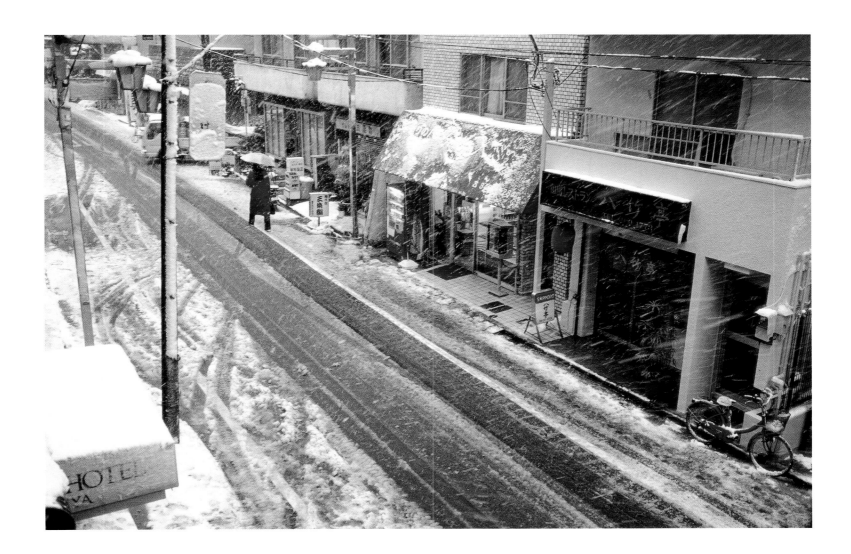

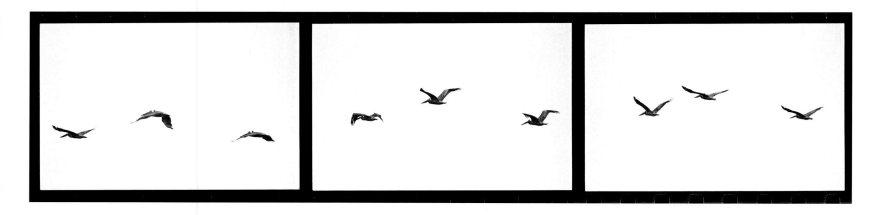

PELICANS, SANTA CRUZ CA, 1998
PIGEONS AT TRAFALGAR SQUARE, LONDON, 2001

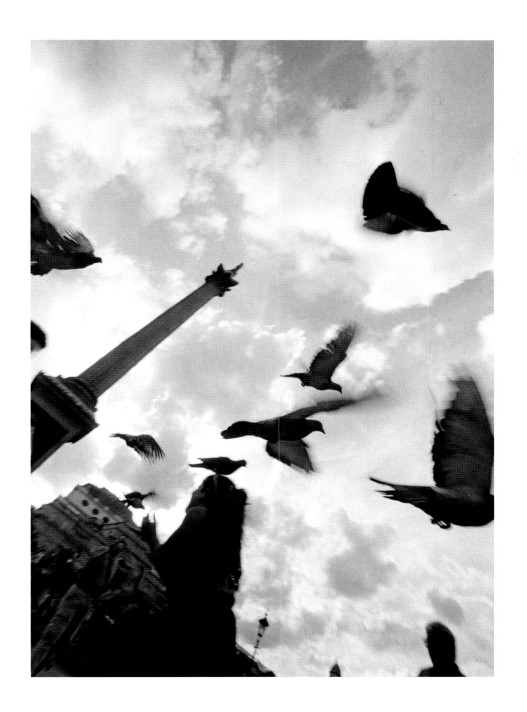

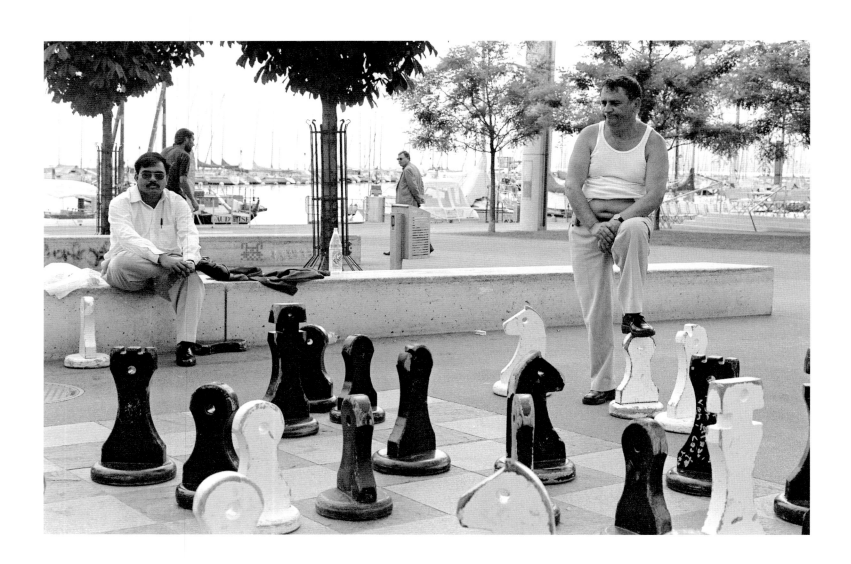

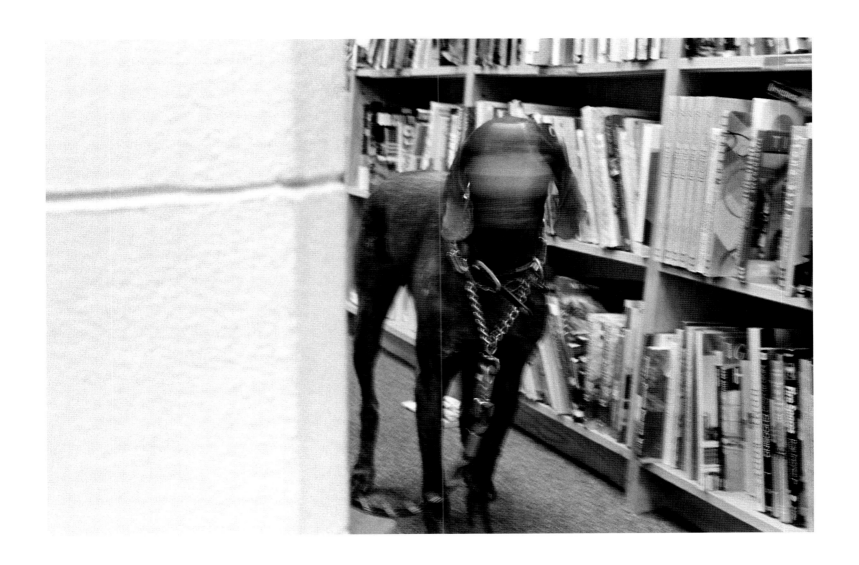

STREET CHESS, LAUSANNE, SWITZERLAND, 2002
DOG SHAKING HEAD, PALO ALTO, 2004

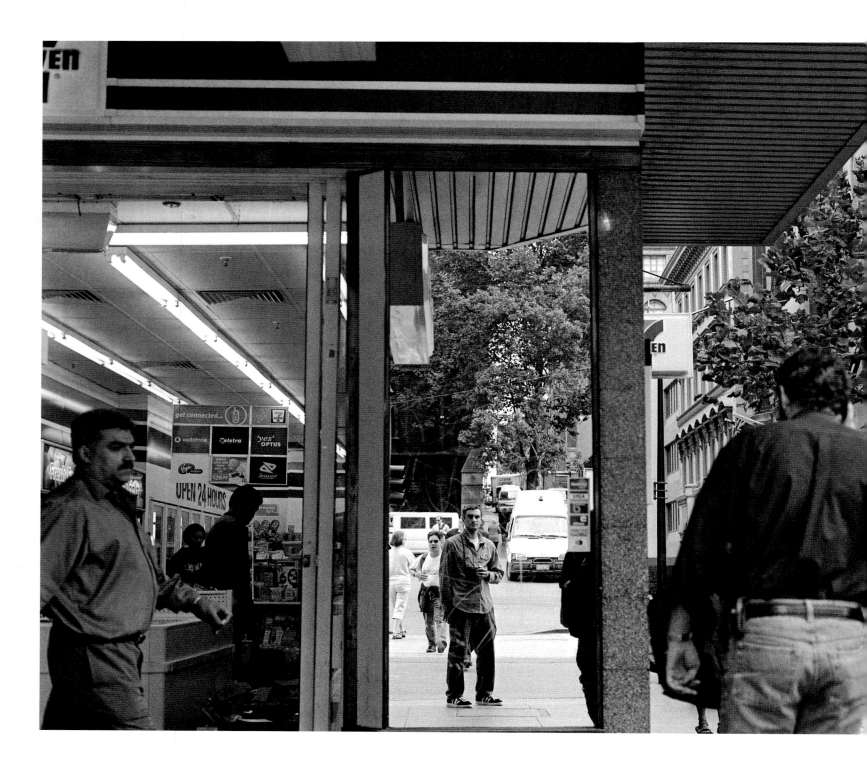

SELF PORTRAIT, MELBOURNE, AUSTRALIA, 2003

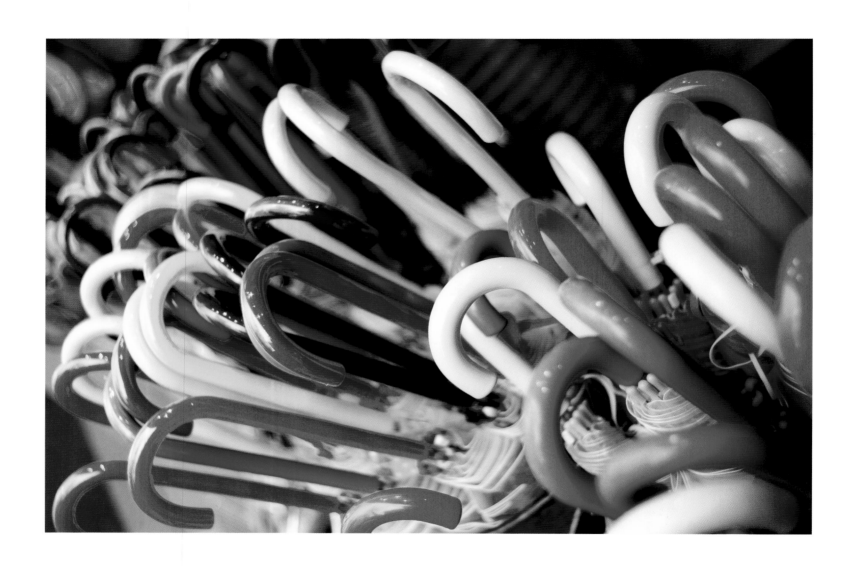

UMBRELLA HANDLES , TOKYO , 2008
BUILDING LIGHTS, TOKYO , 2008

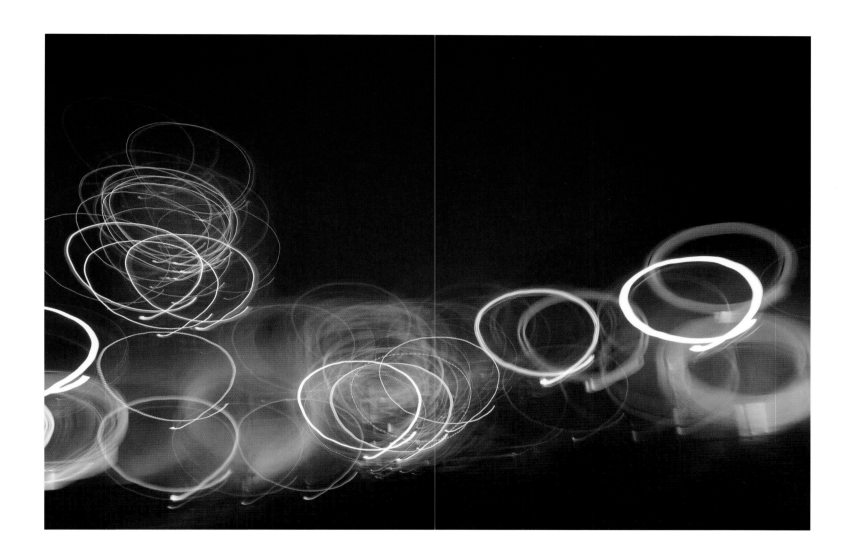

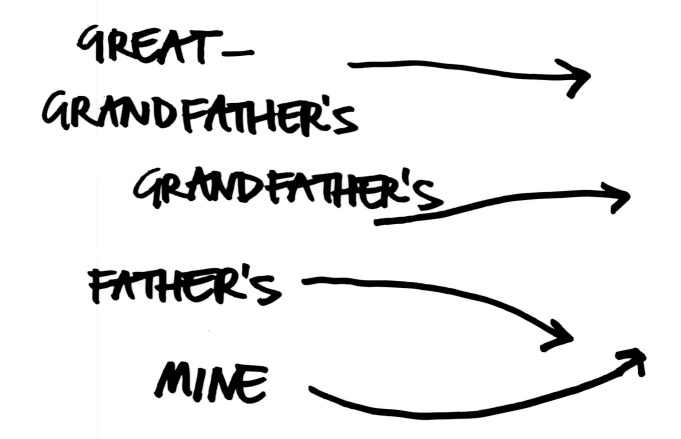

FOUR GENERATIONS OF CAMERAS, SAN FRANCISCO, 2001

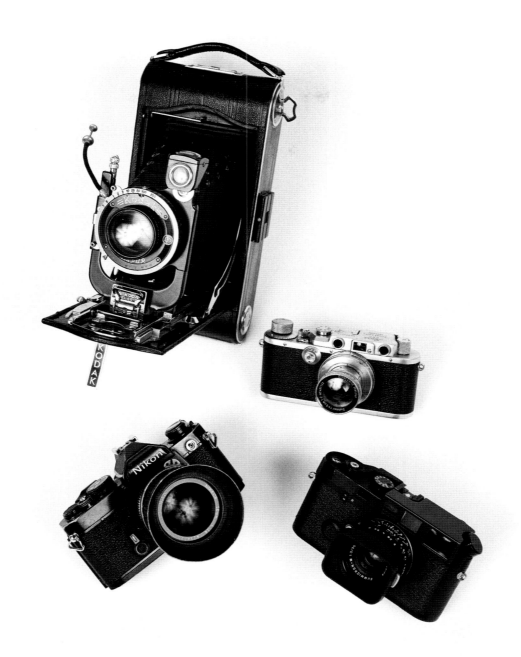

MUSIC

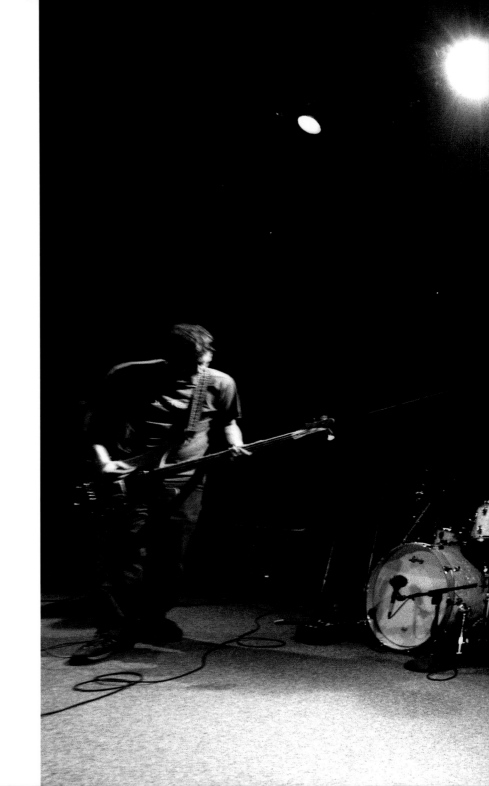

MODEST MOUSE, SAN FRANCISCO, 1999

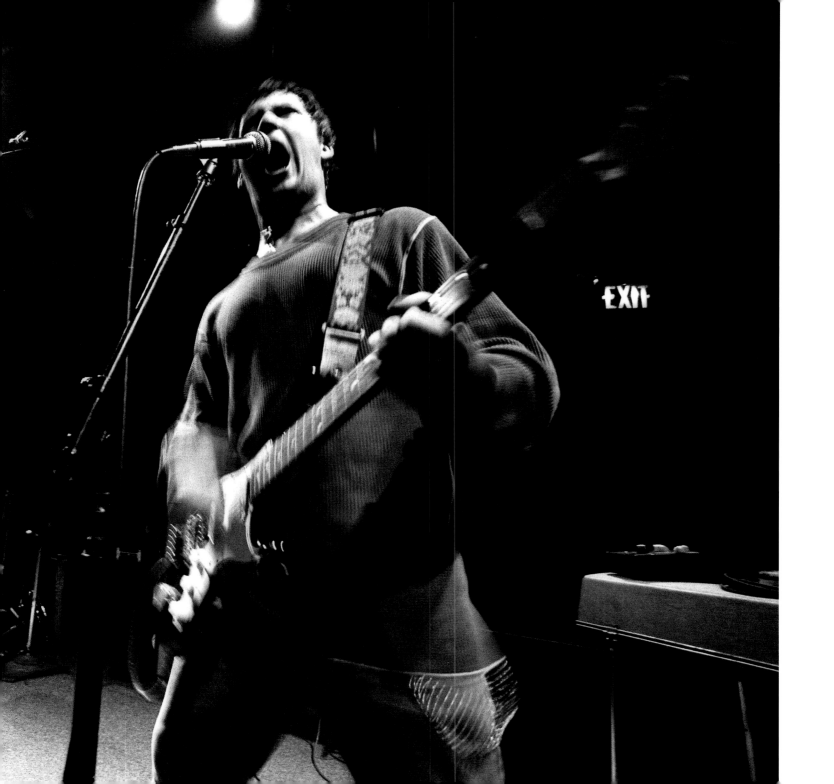

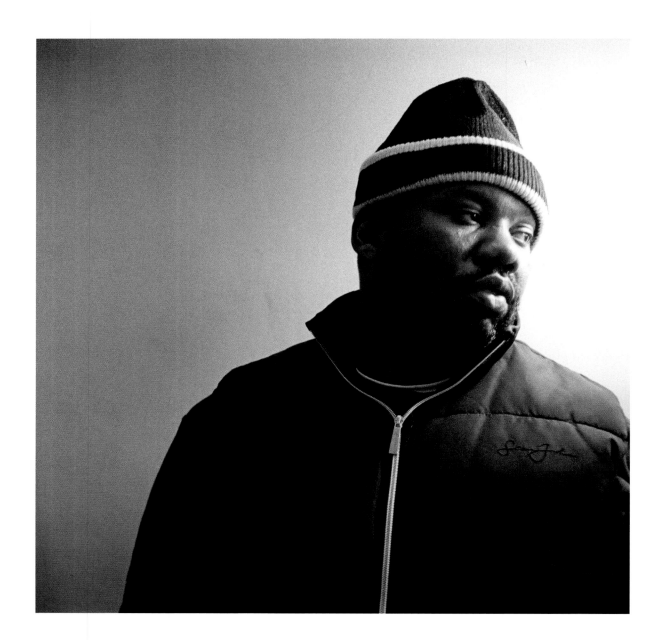

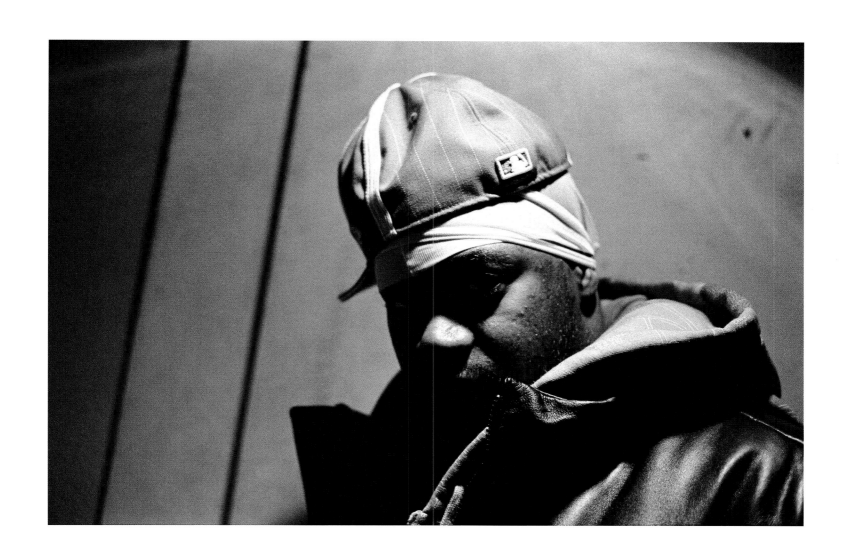

RAEKWON , SAN FRANCISCO , 2008
GHOSTFACE , SANTA CRUZ CA, 2007

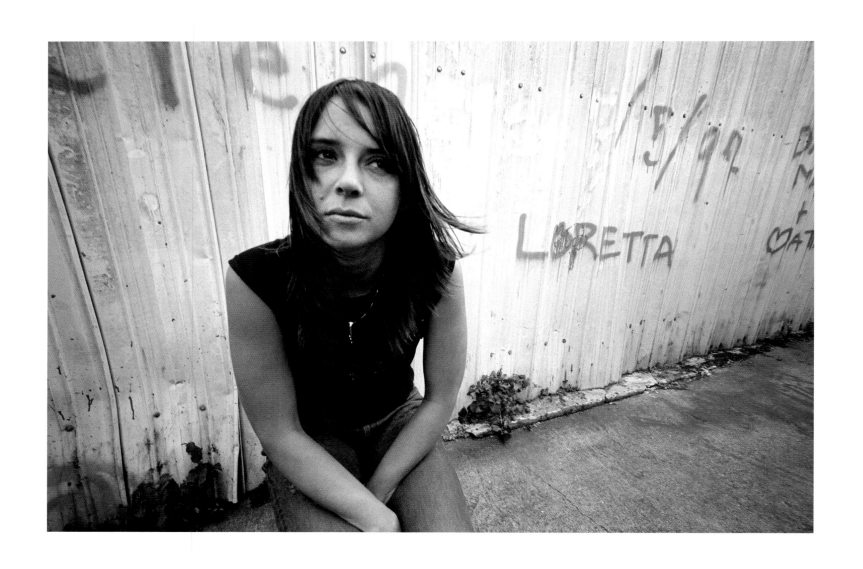

CHAN MARSHALL, SAN FRANCISCO, 2000
LAETITIA FROM STEREOLAB, SAN FRANCISCO, 1999

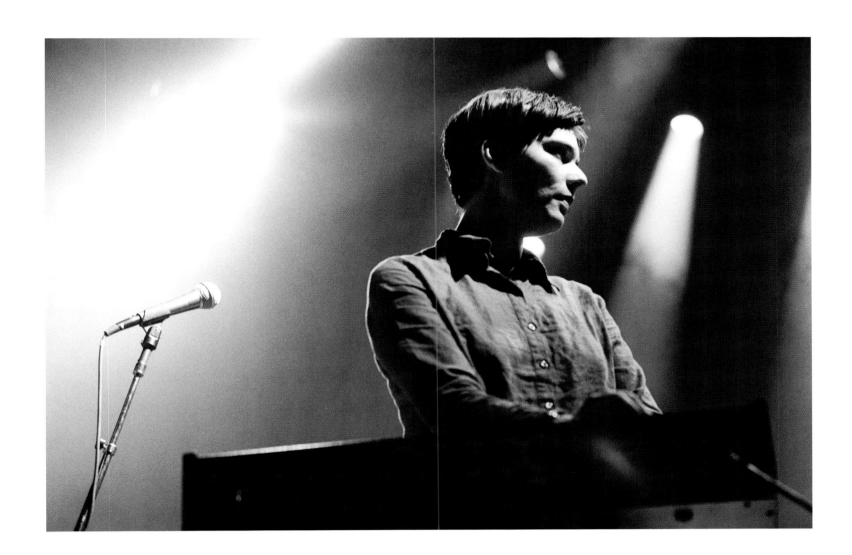

MARK MOTHERSBAUGH, LOS ANGELES, 2007

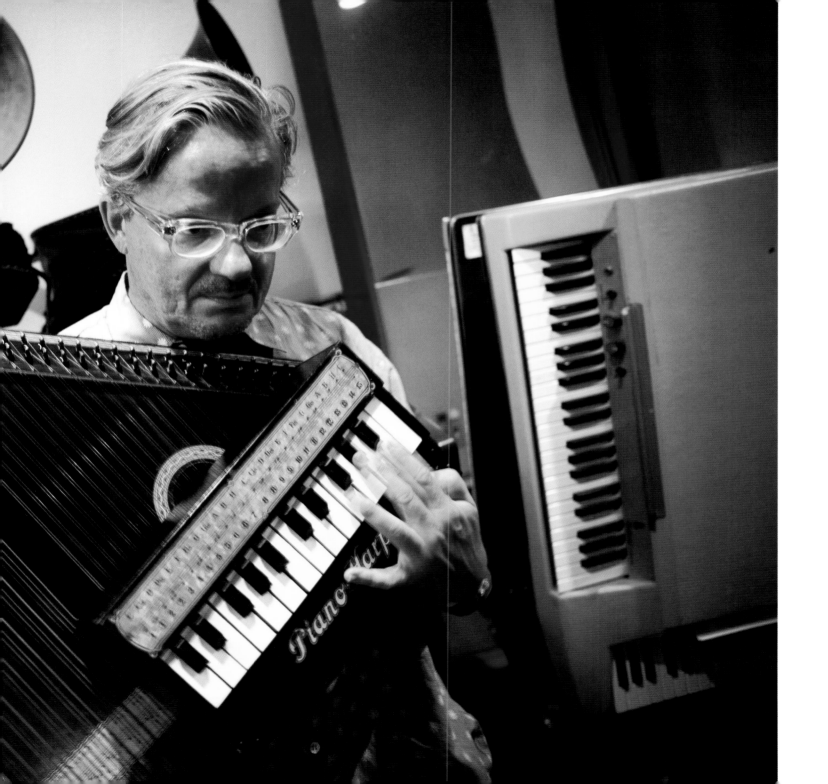

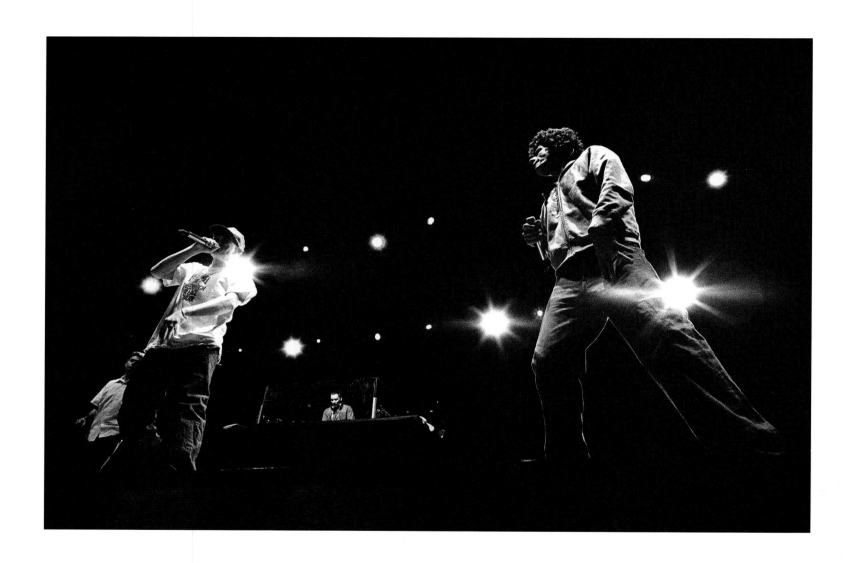

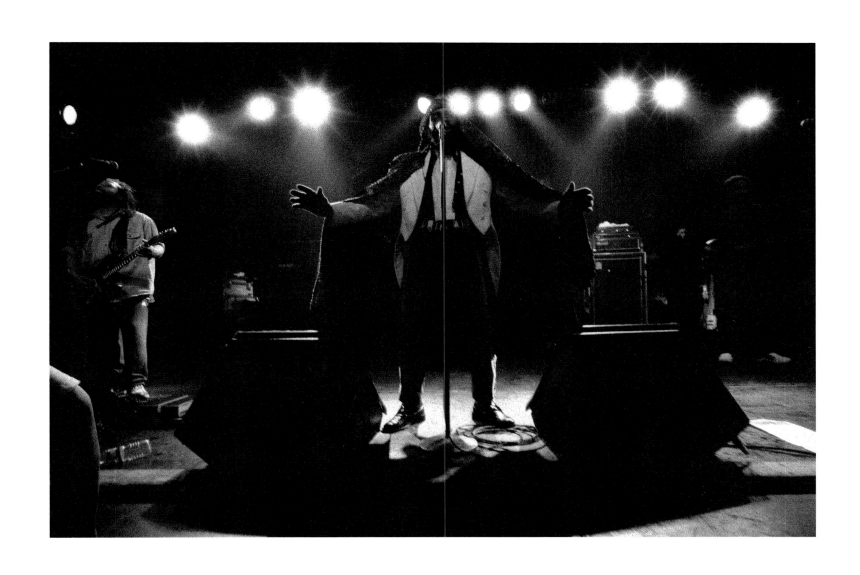

BEASTIE BOYS, LAKE FOREST CA, 2006
BAD BRAINS, SAN FRANCISCO, 1999

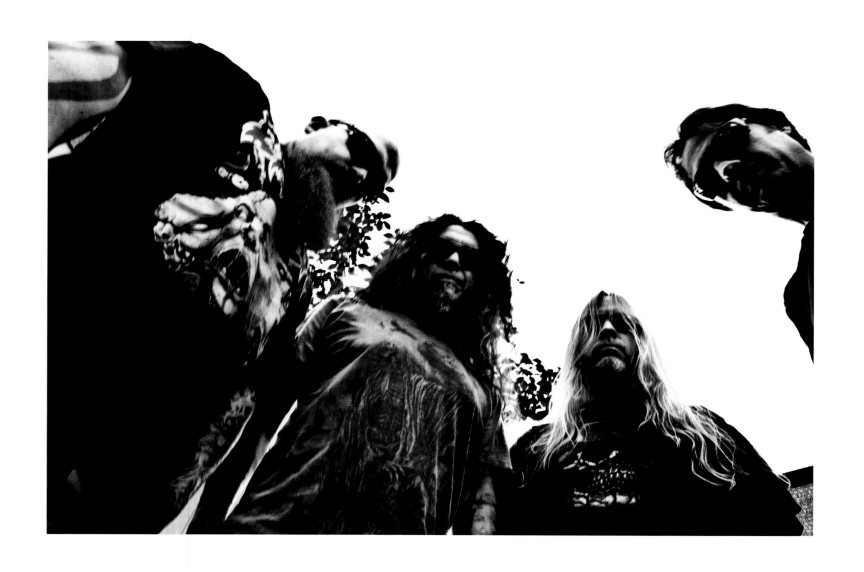

SLAYER, MOUNTAIN VIEW CA, 2009
DEVENDRA BANHART, SAN FRANCISCO, 2004

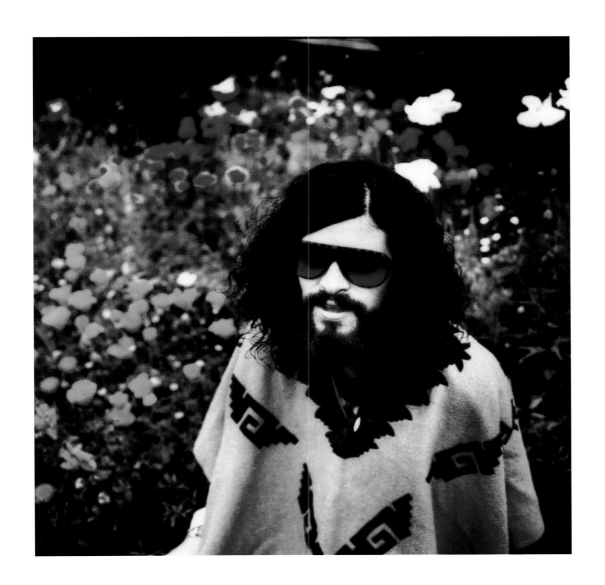

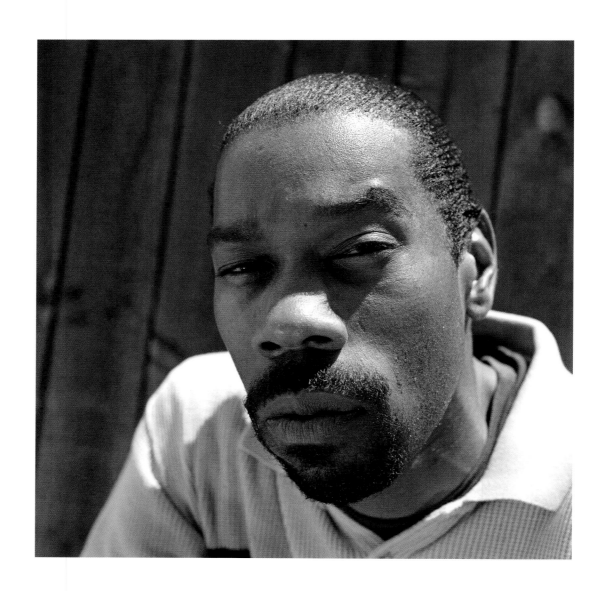

ANDRE NICKATINA, OAKLAND, 2003
TOO $HORT, OAKLAND, 2008

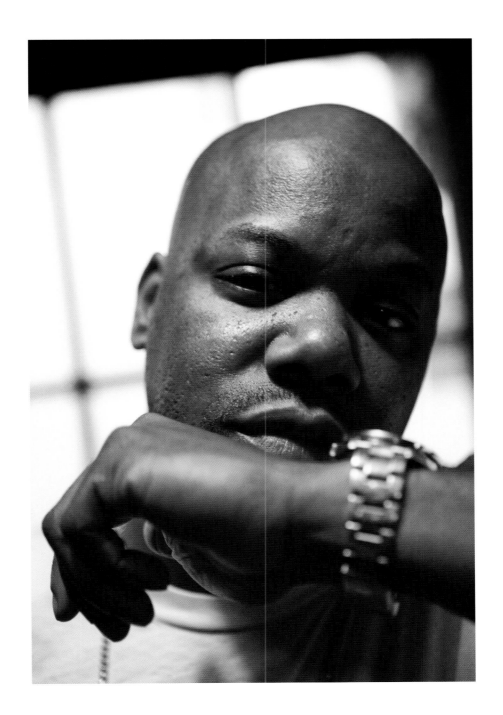

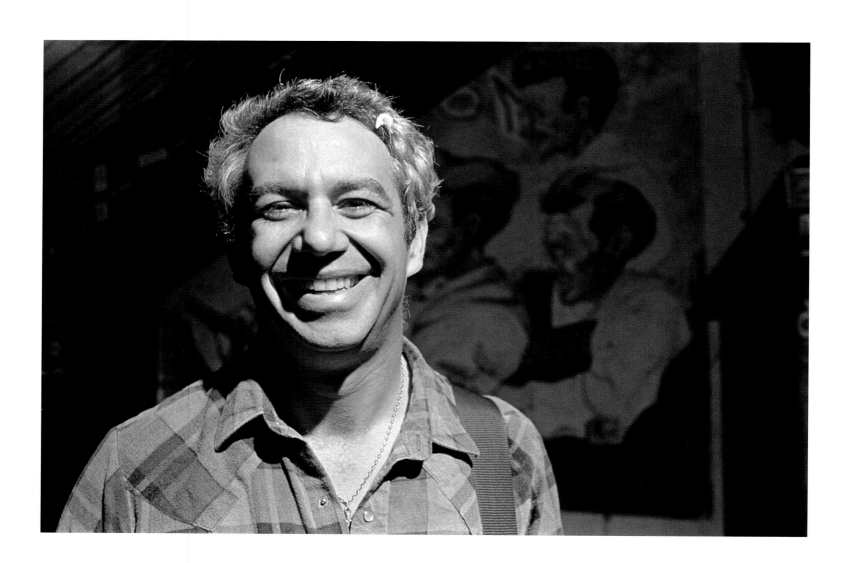

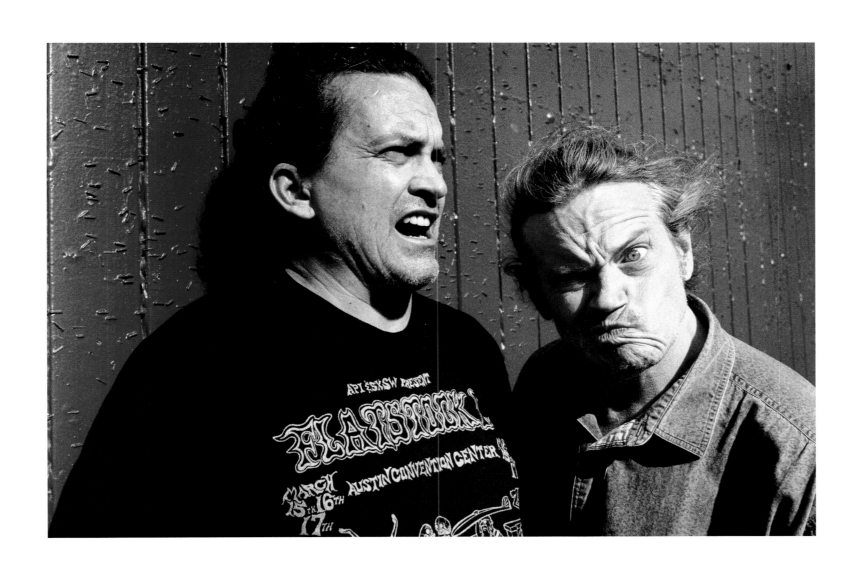

MIKE WATT, SAN FRANCISCO, 2001
THE MEAT PUPPETS, SAN FRANCISCO, 2007

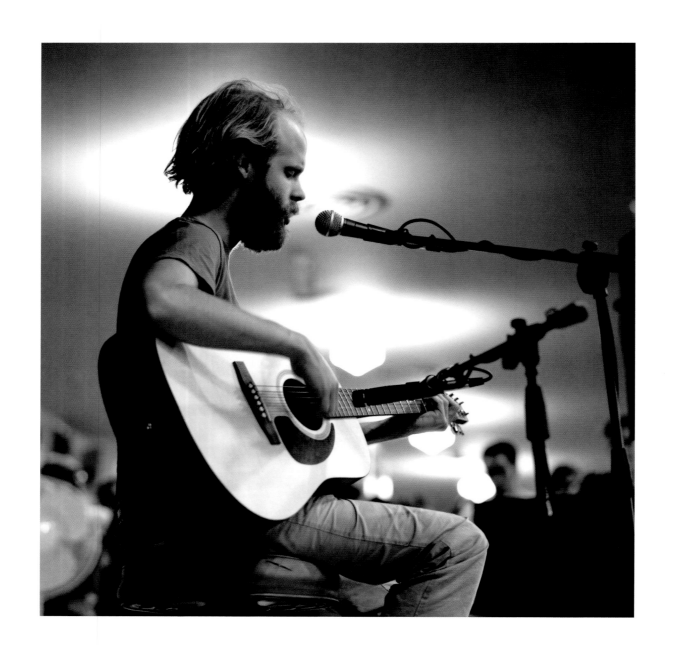

WILL OLDHAM, SAN FRANCISCO, 1998

DAVID PAJO, SAN FRANCISCO, 2004

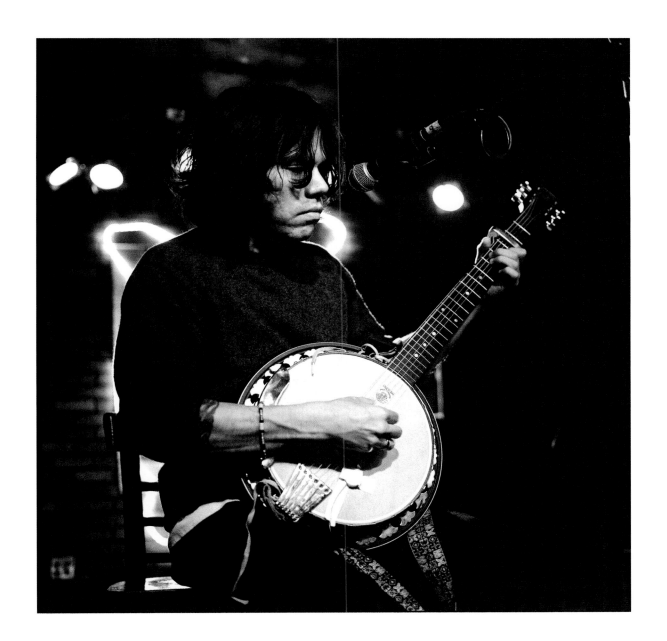

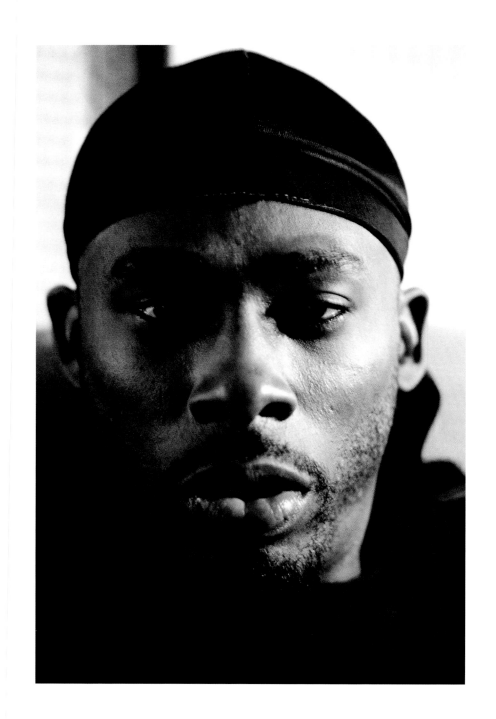

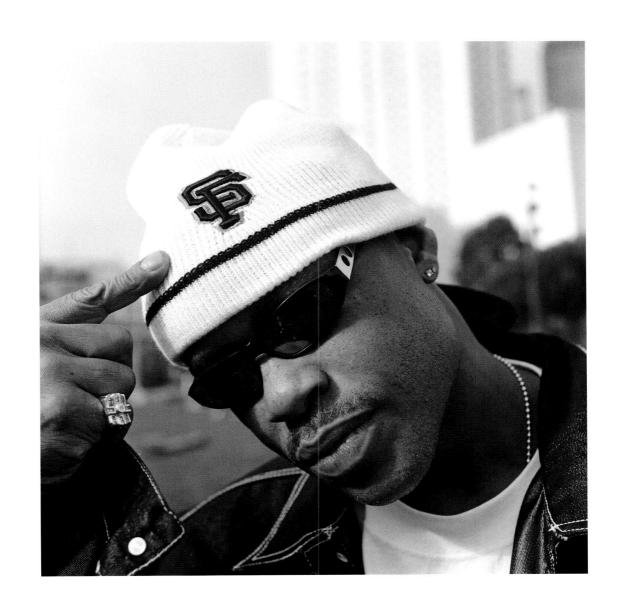

GZA/GENIUS , SAN FRANCISCO , 1999
GURU , SAN FRANCISCO , 2000

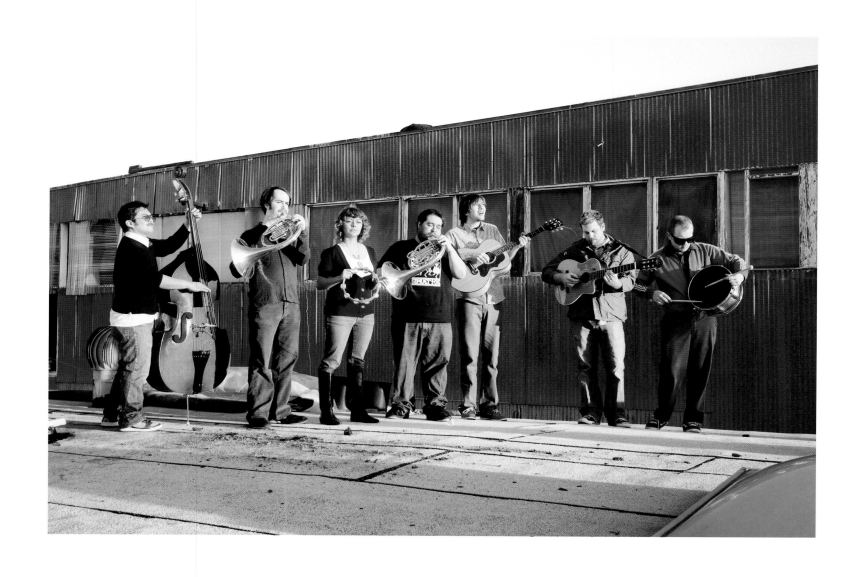

THE MUMLERS, SAN JOSE, 2008
THE DIRTY 3, SAN FRANCISCO, 2003

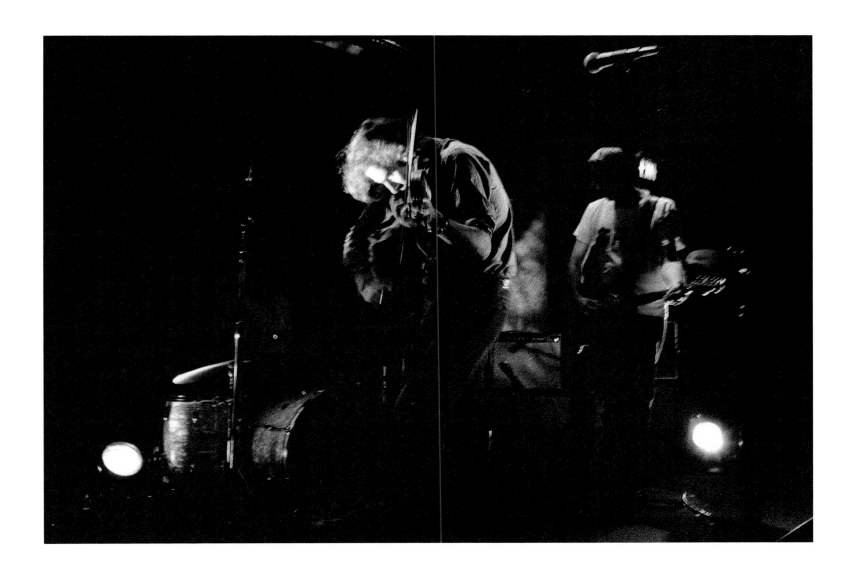

DEL THA FUNKEE HOMOSAPIEN, BERKELEY CA, 2000

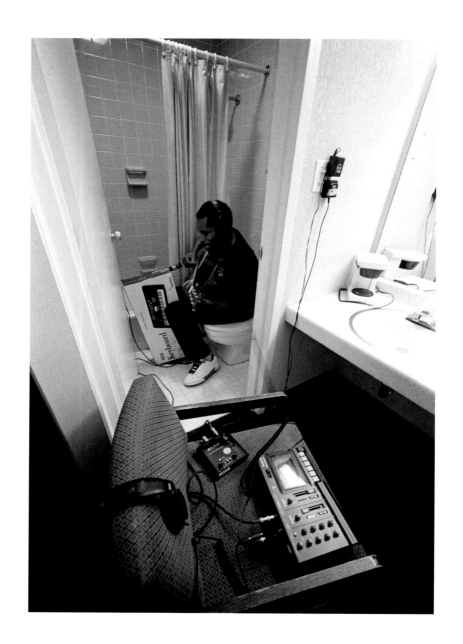

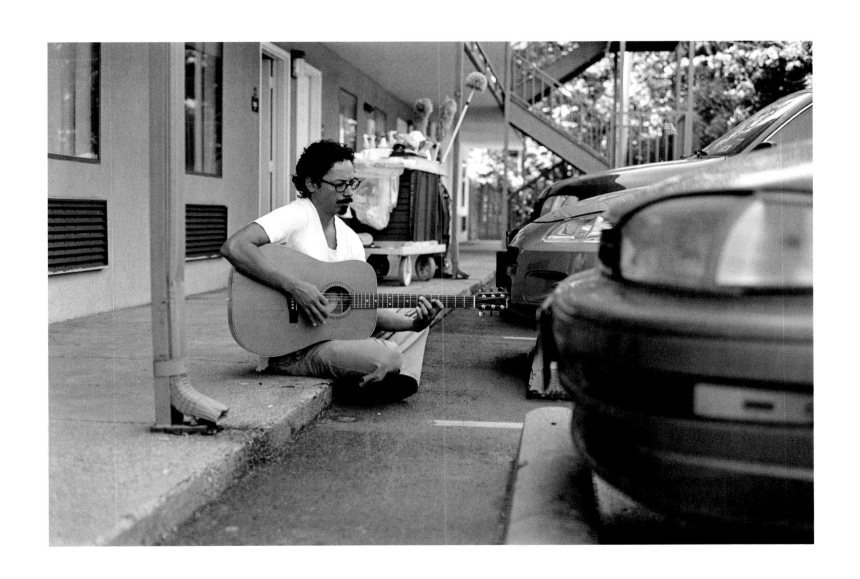

RAY BARBEE, CLARKSDALE MS, 2002
TOMMY GUERRERO, MEMPHIS TN, 2002

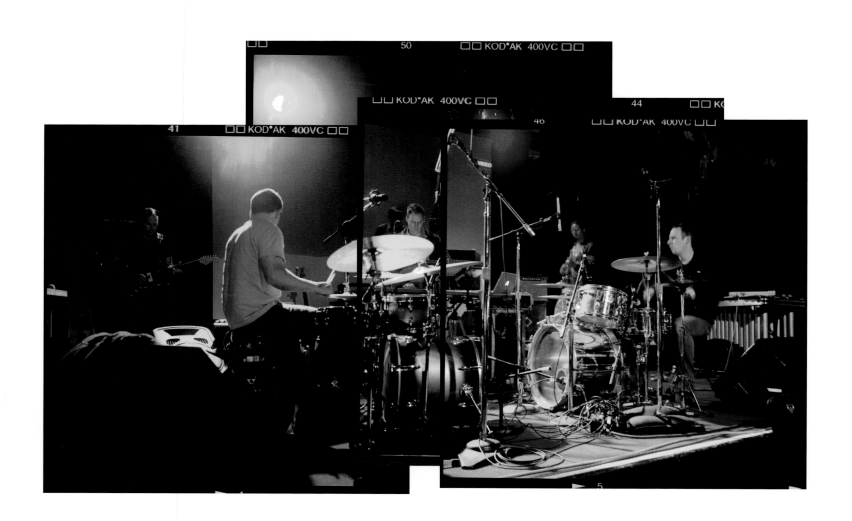

TORTOISE, SAN FRANCISCO, 2004
THE SEA & CAKE, SAN FRANCISCO, 1999

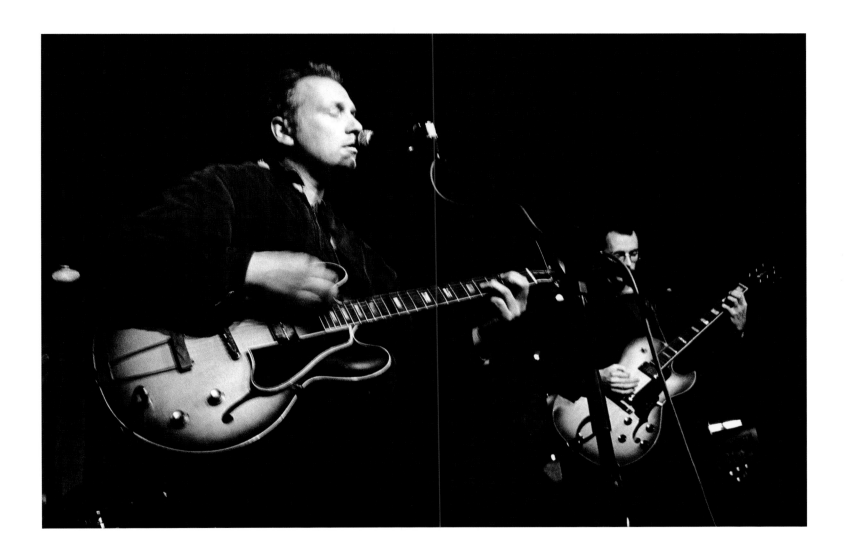

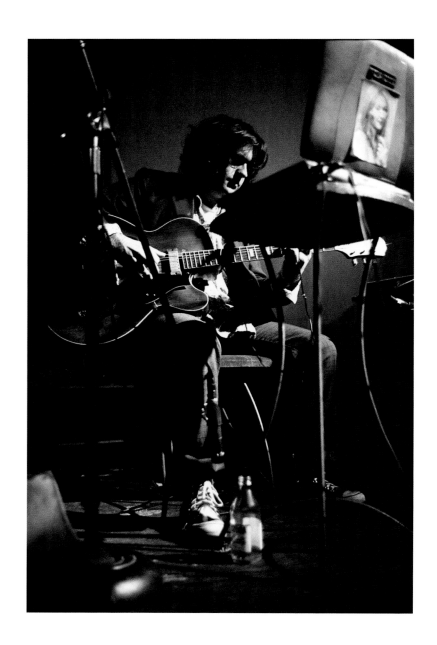

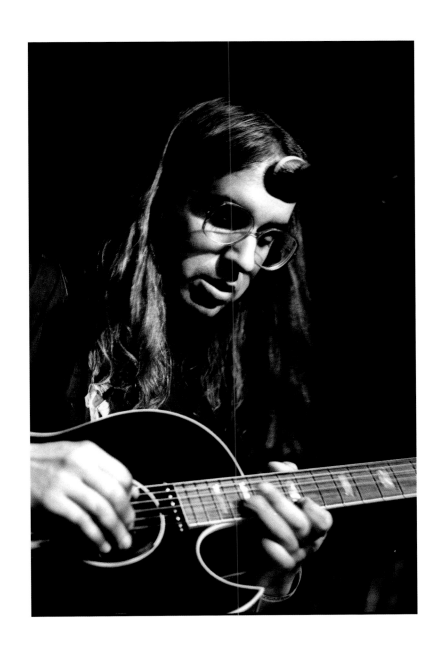

JIM O'ROURKE, SAN FRANCISCO, 1999
J MASCIS, SAN FRANCISCO, 2000

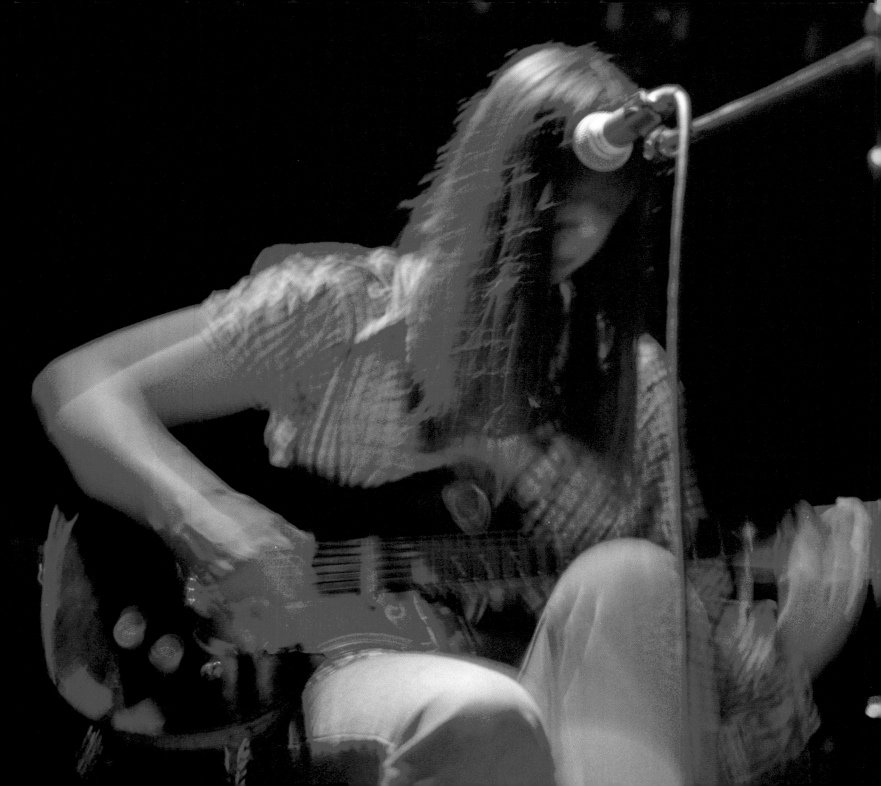

CHAN MARSHALL, SAN FRANCISCO, 2002

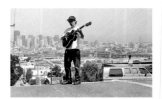

TOMMY GUERRERO — SF

For a music feature in the mag I dragged Tommy up to an intersection in Potrero Hill with a scenic overview of downtown SF to get him against the skyline of the city he is associated with all around the world. He noodled away with some blues, constantly making sarcastic comments and laughing, as he does. One of the best hero–turned–real–friends imaginable.

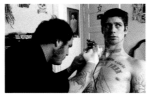

SCOTT BOURNE

A poet, a brute, a lover, a fighter, and above all else a live wire. Scott Bourne is a teeming mass of conflict—pain, joy, strife, pleasure, indulgence, resistance. Never a dull moment. Getting "Unleash or live on a leash" across an already full chest at a friend's house. Shot with a borrowed camera 10 minutes after getting the call to come by. I like how his face looks like Kramer's face in the poster behind him.

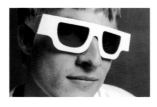

JON EHINGER

The most unique and awesomely unusual guy I've had the pleasure of working with during my decade at SLAP, Jon Ehinger—who was the art director when this picture was taken. He'd written some little story about skating in 3–D and I was shooting the glasses by themselves to go with the words, and just asked Jon to put them on at the end. I think it says something about his truly different way of seeing things, which I really appreciate. He's an art therapist now.

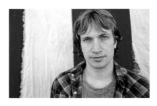

JAMIE THOMAS

I returned from a few days with Jamie Thomas and Joe Brook in southern California on the night of September 10th, 2001 and woke up the next morning to a huge shock. Later that week Jamie came up to SF to oversee the finishing touches on the interview for SLAP he'd been working on. We had a huge American flag hung on the side of the building in the aftermath of 9/11 and I got a few photos of this blue–eyed southern boy in front of the dramatic red and white stripes. Jamie is a pretty good example of making the possibilities of the American Dream a reality.

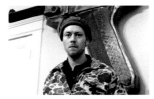

MARC JOHNSON — CAMO

Marc Johnson is probably the person I know who most likes to play dress up—fake teeth, wigs, glasses, shaving cream, toy cigars, hunting outfits—it's all been rocked by MJ. New Year's Eve party at The Mansion in San Jose. His brain is the trigger.

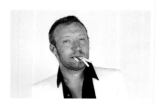

DAN DREHOBL

Totally ripped off from a Steve Martin comedy album centerfold. I stuffed Drehobl in this white suit I have that belonged to my grandfather, and it was so tight we had to leave the pants unbuttoned. Smash up a couple smokes, get sarcastic Dan in the mood, and boom. Shot in the studio at SLAP.

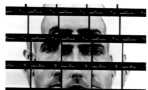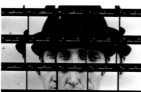

**MATT HATHAWAY
JASON ADAMS**

The one of Halba was a test for the one of Jason to see how the spacing would go. I used the one of Jason in SLAP and always liked it, but the one of Halba always was the better one to me because it didn't line up as precisely. I love the sense of motion in it, how you can't quite focus on one thing in the picture. Shot with a 100mm macro lens next to some train tracks before a session.

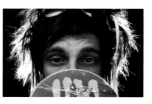

JIM GRECO

This was shot in the studio at SLAP and used for the cover of the issue Greco's interview was in. I had the vision of this photo in my head and he tried to shoot it with another photographer in LA but it didn't look right, so when he came up to do the interview with me we re–shot it and got it how I wanted it. We had a big internal debate over whether or not to use this on the cover because he's known and controversial for too many non–skate photos in mags, but it seemed like such a strong image that we just went for it, with no other text on the cover. It ended up being hated by many but also was the best selling issue of the magazine ever.

**JASON JESSEE —
SCULPTURE**

One of the best styles ever on a skateboard, but more importantly one of the coolest people I have ever been lucky enough to befriend. Jason Jessee has definitely had a huge impact on my life. Not a lot of people know but he is a really gifted artist and sculptor in addition to his skateboard and car/motorcycle skills. This photo was shot at his warehouse in Watsonville, and used for an artist Portfolio profile in SLAP.

TONY COX — STUDIO

Tony was a guy I should have met long before I did just due to the skate crowds we ran in, and even though we didn't, from the moment we met it was like we had been friends for a long time. This is the first photo I ever shot of him and the immediate and total openness he has is visible. SLAP studio.

JESSE ERICKSON

One of the toughest but nicest guys I know, Jesse Erickson, looking very gentle. It was either this one or the one a couple years later where his beard is three feet long, his head is shaved bald and he's wearing loc sunglasses and a wife beater, but I always like when I can get the tough guys to be soft for a moment or two.

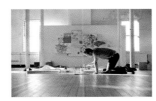

THOMAS CAMPBELL — STUDIO

Thomas was getting a profile in Juxtapoz and requested that I do the story and photo, as we had become friends and he liked my words. I took my wife and daughter with me to the studio he had a residency in up in the Marin headlands for a day's visit. I had brought a shared digital camera from work that I hadn't checked for a memory card only to discover that there wasn't one. Saved by the M6 and Tri–X. Afternoon light while Thomas continues his supremacy.

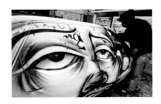

BARRY MCGEE

Shot at the Untitled 2001 week–long skate/art/music multi–venue event all around Tokyo — probably the single best collision of all the stuff I'm most into that I've been lucky enough to be involved with. Barry McGee and friends spent a few days painting these intricate murals all over these crappy cars for a multi–dimensional display that culminated in a festive smash–em/crash–em derby where the cars were totaled in a matter of minutes. Barry ended it by plowing through the fence that kept the people watching out of harm's way and then somebody threw an oil barrel into the window and that was that.

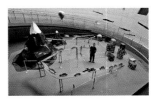

CHRIS JOHANSON

Shot at the Spiral Gallery in Tokyo during the Untitled 2001 event. I met Chris on this trip and dug him from the get–go. He spent several days throwing this whole 3–D cityscape together. I happened to be there as he was finishing it up and got him to stand in the middle of his chaos. Some of his fans there said upon meeting him, "I like to see you" and he and I have always greeted each other that way since. Great human.

JEREMY FISH — GALLERY

I've known Jeremy for about a decade and watched him change from working in a t–shirt print shop to being an internationally renowned artist, and with sincere feeling I say it couldn't have happened to a better, more talented, dedicated and nicer person. I'm really happy to have played some small part in helping that along when we intertwined during the time he did his comic for SLAP, and now I just enjoy watching my friend do his amazing thing. Upper Playground, SF.

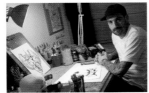

JEREMY FISH — STUDIO

This was shot in Jeremy's home studio in North Beach. I interviewed him for an artist Portfolio that day as well, and we spent the day walking around his neighborhood, talking and catching up. He took me to his local coffee spot, which turns out to be the café where Coppola wrote "The Godfather." Jeremy always has the best details.

SELF PORTRAIT

My wife used to work night shift at the hospital so we got these thick black curtains to keep the daylight out while she slept. Here the mid–day sun was creeping in around a kink in the fabric and bouncing off a mirror into the otherwise black bedroom.

CAIRO FOSTER

I got heavily into Nan Goldin's photos for awhile, and was praying for dramatic golden light all the time. This last ray of the day's sun on Cairo's face after a session was just what I was waiting for. Gunn High School, Palo Alto.

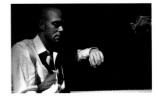

MARC JOHNSON — PIANO

MJ as weathered lounge act. Metaphor? Shot at my mom's house, and in my grandfather's tuxedo. Probably the only time a cigarette has ever been smoked in that house.

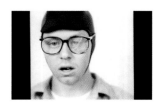

MARC JOHNSON — SCUBA

This is from the first time I ever shot portraits of Marc. We had started an interview that never got finished and I shot a massive amount of portraits one night at his place intended to go with it—he kept bringing out more outfits and props and just having the best time. Eventually I shot up every single roll of film I had and just kept going with Polaroids. This one is my favorite, and because it's Polaroid it's one of a kind.

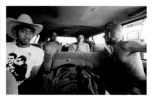

ALASKA VAN

Pro skaters Jerry Hsu, Judd Hertzler, Mike Rusczyk and Tony Cox, all with headwear, somewhere in Alaska. We did a travel article with these guys, and it was one of the most laid–back adventures I've ever been on. We had a great time just cruising around, skating when we found something good, and mainly just freewheeling. This is a good example of the state of mind people get in after a long time on tour in a van.

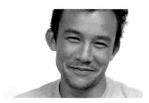

PHIL SHAO

A supremely gifted skater and one of my closest friends, Phil Shao. He tragically passed away far too young, coincidentally on my birthday, so at least I know I'll never forget him. This is the only formal portrait I ever took of him, about nine months before he died. It really shows the Phil that I remember. Miss you, holmes.

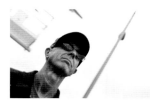

CRAIG STECYK

While doing an interview and portrait with Craig Stecyk for Juxtapoz in LA he toured me around an afternoon's worth of backstreets, bridges, radio dish clusters, oil rigs, Hawaiian restaurants, and other Stecyk–isms that only make sense when you stop trying to understand. Just outside the LAX.

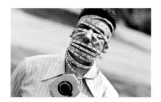

LANCE MOUNTAIN

Not that I didn't love his tricks and style too, but Lance Mountain was the first person to show me that skateboarding wasn't just about the tricks, it was about personality, outlook, approach and most of all enjoyment. Great skater, great comedian, great influence on many generations.

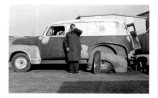

JASON JESSEE — VAN

This scene says a lot about Jason— broken–down vehicle in a personal junkyard, standing embarrassed in an apron, skateboard lurking nearby. In fact it might say just about everything.

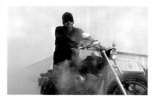

JASON JESSEE — MOTORCYCLE

Jason had just finished building this bike for a guy who was literally on the way to pick it up when I came by, but Jason wanted to do a burnout for the photo and sat there smoking the tires for a solid minute while I shot. The previously brand–new rear tire that the guy had probably already paid for was mangled, but Jason didn't care. The look on his face is great.

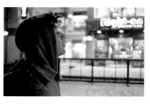

MARK GONZALES

Taken the first night we all arrived in Tokyo for the Untitled 2001 event. Many of us were staying at the same little hotel in Shibuya and we went out for a walk in the snow to stave off the jet lag. Gonz, just taking it in. He ended up staying awake for several days and running through the streets naked. I love how it says "right on" in the neon lights behind him. My favorite skater of all–time, hands down.

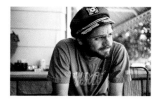

LOUIE BARLETTA — PORCH

Louie is known for being really goofy, laughing hard, and having a good time all the time, so this moment of quiet here is a pretty rare glimpse at the other side of Lou that you don't see much—the thoughtful, grown–up one. He looks like an old sea captain staring off into the waves. Maybe it's just the hat.

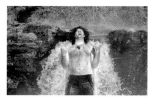

DAVE DUNCAN

On an amazing two–week romp around the north island of New Zealand, and this was the best day of the trip. Beautiful natural hot spring attached to a cool river in Taupo, right across the street from the local skatepark. The water was so hot at the source that you had to build up your tolerance and move slowly towards the falls where it was coming in. This is super skate emcee Dave Duncan in the throws of flesh–melting ecstasy.

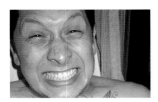

HUNTER MURAIRA

Nike skate team manager Hunter Muraira with recent Morrissey lyrics inked across his chest in hotel meltdown mode on the most extravagant skate trip I ever went on—three countries in two weeks across Asia. First class all the way, literally. Hunter kept like 20 people in line, though not including himself.

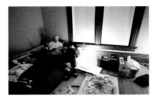

ENJOI HOUSE

Taken at one of the many flop–like houses in San Jose that were inhabited by some of my best friends who are also some of the best skaters in the world. This was right after enjoi skateboards was first started, and Marc Johnson, Jerry Hsu and Louie Barletta all lived in this house and rode for the team. It's kind of a time capsule photo for me, a moment right at the peak of an era.

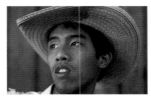

JERRY HSU — HAT

Somewhere in the midnight summer sun of Fairbanks, AK, Jerry Hsu stares westward, crowned with loot from the dumpster just a few feet away. Very Brokeback. This hat stayed with us the remainder of the trip and was rocked by all.

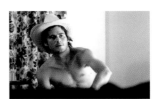

TONY COX — HAT

Again, the infamous Alaskan dumpster cowboy hat. This time in a hotel at 2:00 am, with Tony looking right off the set of a gay porn shoot or a Calvin Klein ad rep's wet dream.

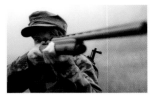

LOUIE BARLETTA — SHOTGUN

This was the opening spread of an interview Louie had in SLAP. We went out to some land his family had some stake in where there was hunting to be done. The original idea was to bag a deer or something and have a full-on gnarly dead animal over his shoulders in the portrait, but we didn't see much out there that day. Instead we shot a bunch of different guns at a bunch of different cans (my first time), and had to settle for this portrait.

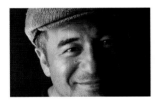

STEVE CABALLERO

Steve Caballero is a straight–up legend to multiple generations of skaters, myself included. This was shot in the studio at SLAP, one of the first digital photos I ever took. The expression in his eyes really shows his personality.

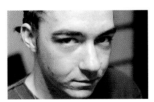

CASWELL BERRY — BRAIDS

This is the young Caswell on an enjoi trip to Hawaii, right before heading out to a party with fresh thug–life cornrows in effect. We stayed in a shack–like house right on the beach in Kailua, and because I came in a day late I missed the last bed and got the floor—which turned out to be just fine as the last bed turned out to be infested with some bugs that gave Jerry Hsu quite the rashy beating.

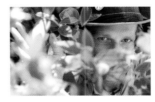

MATT FIELD — BUSHES

Matt is the modern mystic gypsy on a skateboard, and I think if he could he'd probably stay in the flowers all day long. He saved my skateboarding life for a while and I'll always owe him for that. Shot at his friend's house with a rock ramp built into the landscape on top of Mt. Tamalpais in Marin County, CA.

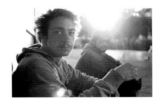

CASWELL BERRY SUN

This is the grown–up Caswell sitting in the sun at the end of a skate day. I had gone to shoot a sequence of another skater who never got his trick that day. As the light waned I kept looking over at Caswell across the way and wishing I was closer to get him in that glow. Finally the skater threw in the towel and I walked right over to Caswell, poked him on the shoulder to get him to look my way and took this single frame. It was the only frame I kept from the whole day, but definitely more memorable to me than just another trick.

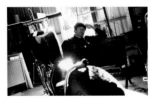

JASON JESSE — WAREHOUSE

The more time I get to spend with Jason the more of his persona behind the public one comes out, and at this point I feel like I've gotten to know the man and not the character. Calm end–of–the–day pause in his "live/work space" just a few paces away from his pet chickens.

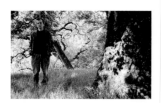

ARI MARCOPOULOS

I first saw Ari's photos in a Transworld in the mid–90s and was shocked at the photographic intersection of so many of my interests—one guy was shooting both Basquiat and Julien Stranger? His work was very influential on me, and meeting him turned out to be great—we clicked really well, him saying I reminded him of himself at a younger age. He was really open and welcoming, inviting myself and Joe Brook to his place in Sonoma and just walking us around the property for hours, talking. One of my all time favorite photographers.

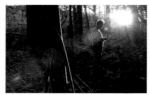

THOMAS CAMPBELL — WOODS

Thomas and I took a walk in the woods while he collected leaves for a sewn piece. This whole scene is very Thomas to me.

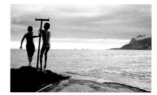

KIDS ON ROCKS

Out on the point where the Ipanema and Copacabana beaches meet in Rio De Janeiro, and near the ancient skatepark we had just skated, two kids were diving into the ocean and playing on the rocks. This is probably my most National Geographic moment.

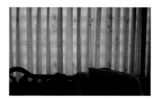

CURTAINS

The view every morning at my in-laws' apartment in Tokyo. Golden light to start every day was nice.

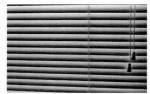

BLINDS

At our apartment in Palo Alto. These blinds used to fascinate me for some reason. The geometry of the intersecting lines, the weird balance of the pull strings, that the scene was black and white even in color, plus back–lit things always attract me. I really like the every—day things in your life that have this almost unnoticeable beauty about them.

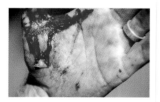

MIKE'S BLOODY HAND

My friend Mike had this skate–induced palm wound that wouldn't heal and kept re–opening all the time. This was one of those times. He referred to it as his Jesus Palm. The photo was used in SLAP for a short–lived (but one of my favorite) monthly departments called The Reason Why. That one was about the merits of slamming.

CHERRY BLOSSOMS

Spring in Japan. Cherry blossoms are far from rare but still nice to gaze upon. Good opposite Mike's bloody hand—a nice balance of life.

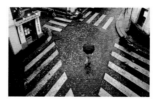

PARIS CROSSWALK

Shot from the window of our hotel in Monmarte, Paris on my honeymoon. My wife and I had taken an overnight train from Nice to Paris and when we arrived it was raining so we just sat in our hotel room with the windows open and enjoyed some rest during a warm summer's storm. I was hoping for a white umbrella, but this worked ok.

TOKYO CROSSWALK

Between work and family trips, I've been to Japan a lot, and specifically to Shibuya. That neighborhood, and that crosswalk particularly, have been good to me. The stripes and feet of the second—floor Starbucks patrons and the stripes and feet of the cross—walkers below caught my eye.

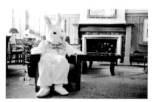

EASTER BUNNY

My in–laws belong to a country club and wanted all the grandkids to come up for an Easter brunch thing. I was walking to the restroom when I took a short cut through a side room and found the Easter Bunny on break, all by himself. He just stared at me, not a word. I took this photo and kept walking. Probably the happiest I've been to have just happened to have a camera with me.

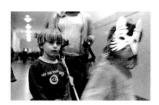

ZEBRA MASK

Kids are so rad, so unfettered by self–imposed adult restraints. Today I feel like being a zebra. I'm gonna wear this mask all day. So what? Maybe I really AM a zebra—what do you know? I'm outta here, time to hit the savannah. Museum of Natural History, NYC.

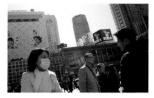

SHIBUYA CROSSWALK

Tokyo is probably my favorite place for street photography because there's so much to see and it's never confrontational. I was big into Gary Winogrand at this time and took every spare moment I had to walk around and just fire away. This is my favorite from the trip—I like how the height, spacing and color of the people mirror the height, spacing and color of the buildings they're in front of so well, that the foremost man and woman are moving in opposite directions and wearing opposite colors, etc. Lots going on in this one.

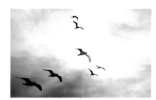

SEAGULLS

Further aftermath of "Memory Screen" (see caption for Pelicans, next spread).

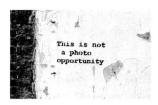

NOT A PHOTO OPPORTUNITY

Banksy wasn't an internationally known name until several years later, and at the time I just thought this was really weird graffiti. Had to snap it just because. This was the original cover of the book until I learned what it was. London, 2001.

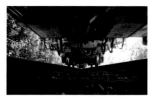

UNDER THE TRAIN

Loaded up a camera that had a motor drive on it, leaned it against a discarded back pack on top of a rail road tie, ran a 20 foot cable release under the track, waited in the bushes for the train to come, squeezed off the whole roll. Not a point of view I'd otherwise get to have, unless I was in some serious trouble.

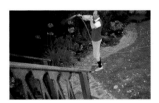

BROWN BAG LAWN CARE

Just another lazy afternoon at The Mansion, home to scores of skaters and good–timers in San Jose. Mike Janway, brown bag lawn car.

STEEP MOWING

Portrush is a beautiful little town on the northern coast of Northern Ireland, and this man was charged with the task of keeping those emerald hills nice and trim. Laying down on this job is mandatory.

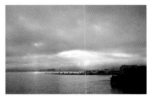

WHARF

Point–n–shot from a hotel balcony in Monterey. Reminds me of a Winslow Homer oil painting, especially with that little ray of light coming through the clouds and hitting the water. Very still.

SUNSET FROM A PLANE

I always feel kind of sad for people who sit in window seats on planes but close the shade. The perspectives and things you see from a plane are so unique and beautiful that they make me appreciate my planet a lot more. Sunset from six miles up.

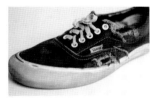

OLD SHOE

One of the longer–skated shoes I ever had. Just felt the need to document all it gave. Polaroid Type 55!

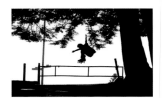

MATT FIELD — OLLIE

A nice little action–meets–art moment. I wasn't framing to do this intentionally, but the way his back and arm follow the line of the branch fits pretty well. This was inspired by a photo my dad took that was hanging in my house as a kid—a silhouette of a similar kind of tree and people walking on the beach.

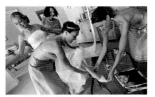

KATIE WEDDING

Despite how most photographers feel about shooting weddings, I really enjoy it when it's for people I care about. We went to Hawaii for our friend Katie's wedding and I spent a few hours backstage with a gang of sisters and their mom as they dolled up for the main event.

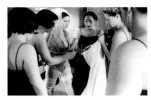

CLARE WEDDING

Another wedding prep moment. Our friend Clare gets a few helping hands from her lovely bridesmaids as she slips into her nuptial attire.

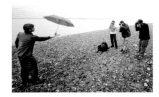

UMBRELLA ON BEACH

On the SLAP trip to Alaska everybody in attendance was a really good photographer. Between the six of us we had like 25 cameras in tow, so everything was documented well. First day in AK on a stone beach in Anchorage, Tony balances while the rest of us squint.

PINK HOUSE

The Pink House in San Jose was literally a huge pink house inhabited by many skaters over the years it was going. Parties were non–stop, couches were constantly being surfed. Eventually the last group got evicted and this was the last day—move out/skate the house party. Last new resident Emmanuel Guzman f/s noseslides the handrail before the session moved to the couch on the sidewalk.

TONY TRUJILLO

The last night of the Untitled 2001 event in Tokyo the organizers took everybody out for beer, bowling, and karaoke. This was after the beer and during the bowling. Tony Trujillo and Max Schaaf bought ski masks and rolled with them on. Tony, seemingly solitary man down although the place was actually packed. Thomas Campbell threw a bowling bowl into the ceiling a few minutes later.

MAID'S DAUGHTER

Outside the same hotel room as the photo of Tommy Guerrero playing the guitar on the curb, just a few minutes later. This is the maid's daughter, entertaining herself with some cleaning supplies. She's got a Stedy sticker on her which was the name of a clothing company that didn't quite happen right after Forties went out. Thumbs up and shaka at the same time, down the street from Graceland.

JERRY HSU — HORSE MASK

I was in Japan on a family trip and also involved in a group show consisting of Jerry Hsu, Jai Tanju and myself at my friend Taro's gallery called Number 12 in Tokyo. This was the last day there and Jerry had found this mask at a store somewhere. I thought this was pretty good, but Jai got the better one on the plane on the way home—Jerry in the mask with the overhead light on him while the rest of the plane was dark and filled with sleeping passengers.

LONG EXPOSURE — DRIVING

About three minutes at f/22 while driving one handed and aiming the camera at all the headlights, tail lights and street lights I passed, on the way home from Trina's house. I was really into long exposures for awhile in college after seeing some stuff of Ivory Serra's.

LONG EXPOSURE — SMALL WORLD

A 30 second exposure while on the Small World ride at Disneyland with my family. I like this because it's the closest I'll come to being Mark Rothko.

PINK SHOES

On a walk in Tokyo when a woman wearing incredibly bright pink shoes crossed the street in front of me. It was the end of the day and the light was going out so her shoes actually looked streaky to my eyes. Had to follow her for a block to try to get those trailers.

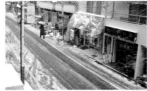

RED IN SNOW

Out the window of my hotel during the Untitled 2001 event. The spots of red always reminded me of an early scene in Buffalo 66 where Vincent Gallo is walking down the street and there all these red lights and signs are popping out behind him. I'm glad she chose that coat that morning.

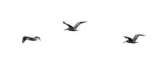

PELICANS

I've been obsessed with pelicans ever since the Alien Workshop "Memory Screen" video did a number on me as a kid. Living in Santa Cruz while going to college I got my fill as they'd fly up and down the coast constantly in search of food. Amazingly bizarre and beautiful creatures. This is the oldest picture in the book.

PIGEONS AT TRAFALGAR SQ.

Trafalgar square in London is famous for its throngs of winged rats. Some people feed them, most people dodge them, but kids love them and I had a good time getting in there with them, too. Got down low with a 15mm lens and just shot as close as I could. Didn't even notice the pigeon on the girl's head when I was shooting.

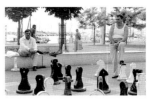

STREET CHESS

I was in Switzerland on a trip for a traveling art show celebrating the 10–year anniversary of SLAP that was coinciding with the summer contest circuit in Europe. This was right outside my hotel. The way the guy is wearing his shirt and standing and the expression on his face just says "I really have no awareness of anything other than playing chess right now, other than maybe that my belly is really hot."

DOG SHAKING HEAD

Taken in the photo section of a bookstore. I came around the corner and there was this dog all by himself, no owner in sight, looking at the books. I started to raise the camera and he turned to face me, shaking his head right as I clicked. Don't know how he managed to wave just his snout while the back of his head stayed still, but he did.

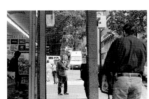

SELF PORTRAIT — STREET

A rare self–portrait/street shot, outside a 7–11 in Melbourne down the street from where we were staying on an Australia/New Zealand SLAP trip. You can see Matt Rodriguez inside the store. I like that it's non–descript enough that it could be any street anywhere—only the police sign gives it any sense of being somewhere "else."

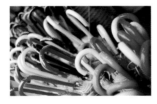

UMBRELLA HANDLES

From another walk in Tokyo. Just some bright umbrella handles. I like finding little things like this.

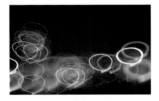

BUILDINGS LIGHTS

In the alley near my in–laws' apartment in Tokyo I stopped to see if I could move the camera at the right speed during a one–second exposure to make a decent circle. I got pretty close on the first try and kept walking.

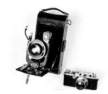

FOUR GENERATIONS OF CAMERAS

The words next to the photo say it all. I've used all four cameras to take my own photos at various times in the last 20 years.

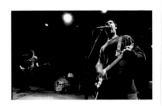

MODEST MOUSE

Shot at the Great American in SF around the time "Building Nothing Out Of Something" was released. Then–SLAP art director Jon Ehinger did the interview and made this strange little mouse mask that he somehow talked them all into posing with individually while we hung out with them back stage. Something was wrong with my camera and only one or two frames ended up coming out of the mask scenario, which is possibly for the better. The guys were really awesome and genuinely stoked to be in the mag. I always prefer non—stage photos whenever I can wrangle it but I think this is my favorite live stage photo.

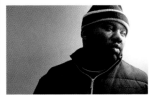

RAEKWON

Ghost was the hardest Wu member to get, but Raekwon was the most personally satisfying to meet and shoot. It was such a great surprise to find him so cool to talk to and so down to earth, especially as a big fan. I brought Halba out to interview again and we both just sat and talked to him alone for a half hour before I shot these portraits. I brought him some older issues of SLAP that he'd been in years before, and he remembered a couple of them, even posing with an issue where his name was on the cover. Grand Ballroom, SF.

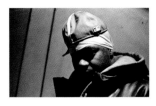

GHOSTFACE

Over the years we'd gotten most of the main Wu Tang guys in SLAP, but Ghostface just never lined up right despite being the one I wanted most. I thought this time was gonna be more of the same, but I got a call at around 8:30 at night saying Ghostface was available at 9:00. I made the 45 minute drive to Santa Cruz in 30 minutes, met up with Halba (who I offered the interview honors to since he and I are Ghostface blood brothers), and got up with Ghost and his crew back stage. He was very quiet and reserved, very serious. I only got to take about four frames of him alone, but shooting him was like reaching the Wu Tang finish line.

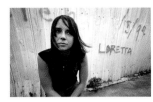

CHAN MARSHALL — ROOF

I met Chan during sound check at the Bottom Of The Hill in SF while she was touring mid–way between the Moon Pix and first Covers records, before she was too well known. We hung out for several hours drinking Stellas and eating grapes on the roof of the venue. She kept wanting to use my camera so there are a couple frames of me that she took on the roll. A couple years later she started hanging out with some of my friends on a regular basis. Small world. Definitely one of my favorite portraits, and she was a great interview and hang–out experience as well.

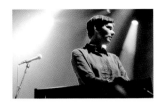

LAETITIA / STEREOLAB

Shot on their "Cobra and Phases…" album tour. Papa M opened with his "Live From A Shark Cage" album in its entirety, plus a 15 minute version of "Turn, Turn, Turn." Good show! Laetitia looked very goddess–like up there with the spotlights swirling around her as she stood motionless for a minute. Fillmore, SF.

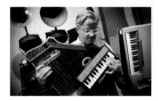

MARK MOTHERSBAUGH

Arranged through my friends at Nike, who had enlisted Mark Mothersbaugh to compose original music for their skate video "Nothing But The Truth." I got to go into Mark's studio on Sunset Blvd in an old plastic surgery facility, meet and spend the day there with him while he worked with a couple Nike riders composing tailor–made tracks for the video. The whole basement (where this was shot) was filled with weird instruments he'd collected over the years, including all the original Devo synth gear. I interviewed him as well, and the whole experience with him was so cool— being in the presence of such friendly greatness was a total honor.

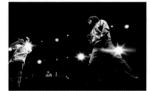

BEASTIE BOYS

Live at the Etnies Goofy Vs. Regular contest at which I was the "coach" for the Regular footers. I first saw them play in 1992 on their "Check Your Head" tour (Cypress Hill and Rollins Band opened on that one, people threw fruit at Rollins) and they still had all the same stage presence. Didn't get to meet them though because they'd only allow one member of the media back at a time and Nate did the interview honors. It was funny to be in the photo pit with all the action skate photographers and all their monster digi cameras and big flashes. I was the only one shooting film. 35mm black and white, and available light at that.

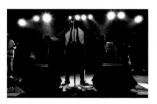

BAD BRAINS

Technically this photo is of the Soul Brains as it was taken while they were touring by that name due to some legal mumbo–jumbo, but c'mon—it's the Bad Brains. HR was practically catatonic the entire show despite the raw power of the band swirling around him so when he spread his arms out like this it seemed really dramatic. My friends Nate and Mike somehow got onto their tour bus while I waited forever at the front of the stage—oh well. Maritime Hall, SF.

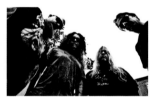

SLAYER

My fascination with metal peaked way back in junior high, but a few bands are just so powerful that they will always be with me- Slayer just can't be denied! The chance to shoot them came up really last minute, but I didn't hesitate to ditch my kids with a sitter and run over to lay on the floor beneath them for five minutes. Bow down! Tom Araya and Kerry King were both very friendly and pulled me up from the floor when I was done shooting.

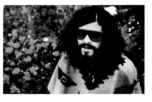

DEVENDRA BANHART

This was shot in the backyard of a house in SF he was living in at the time. He put on the serape and glasses and led me out into the yard, asking if it was ok if he squatted in the flowers. Then he started doing all these weird hand signals saying they meant "skate or die" in Hindu. Nate interviewed him during a car ride downtown during which he relayed stories of vomiting into his friend's mouth, and vice versa. Still, "Rejoicing In The Hands" is one of the most beautiful albums I've ever heard.

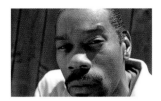

ANDRE NICKATINA

First time I heard Dre Dog I thought it was terrible, but I grew to love it. This was taken at a house studio in Oakland where the "Conversations With A Devil" album was just recorded, and we got to hear the album from him there before it came out. I shot these in the woodsy back yard of the house, which was a weird place to see him given his ultra—urban persona, but he was really friendly and cool, smoking weed with my friend Dave as he bumped the new album for us.

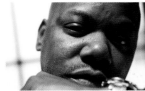

TOO SHORT

This was taken for an interview in Thrasher magazine. A few of us headed over to Too Short's studio in Oakland and spent a few hours doing an interview, shooting some photos and just hanging out as people came and went through the place. His manager kept wanting me to shoot him in front of his gold records in this little corner in the back and nobody got why I just wanted him under the light by the window, but I thought this became a pretty soft portrait of a pretty hard guy, which I like.

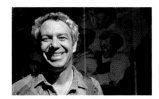

MIKE WATT

Mike Watt is the reason I wanted to play bass, and one of the most influential figures in my life. Meeting him for the first time and getting to shoot a few portraits meant a lot to me. He was so friendly and engaging that I felt like he really wanted to be there talking to me, more so than just about any other musician I've interviewed or shot photos of. He ripped that show at Bottom Of The Hill, especially during the encore when he played chomping on a cigar, sweat pouring off of him, drooling like a mad–man as he man–handled the thunderbroom. That little bit of shaving cream in his hair here always makes me smile.

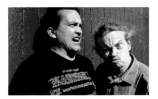

THE MEAT PUPPETS

What a total treat this was. Taken at the Independent in SF during their "Rise To Your Knees" tour, the first album the brothers had recorded together in over a decade. I brought along Stefan Janoski, who was into them via his Nirvana obsession. He'd even skated to Nirvana's cover of their "Lake Of Fire" in a video. I introduced them, told the brothers who Stefan was and that he'd skated to one of their compositions—they were super hyped. I got some frames of the three of them together, but this one with Cris and Curt mugging is priceless to me. And what a stellar show!

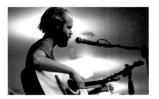

WILL OLDHAM

The first music interview/portrait I did when I started at SLAP in late 1998. He had just started referring to himself as Bonnie Prince Billy, which was a little confusing, but he was great to interview in all his weirdness—we talked for over an hour. Shot at a free show at Amoeba in San Francisco where he debuted much of the "I See A Darkness" album.

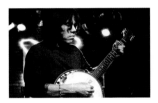

DAVID PAJO

Between Papa M, Tortoise, and Slint, I'd been listening to Dave Pajo for a long time, and was really stoked to meet him. We shot these at sound check at Bottom Of The Hill and then walked together to get coffee at Farleys where I interviewed him and he talked about skating a bunch. He was excited to have just had some songs used in the recent Habitat and Emerica videos, and even gave me his phone number so that I could let him know if more of his songs were going to be in videos.

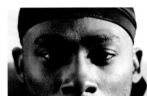

GZA / GENIUS

Shot in some sketchy hotel around 9th and Market in downtown SF. He told me not to use flash or a fisheye lens for his portrait—neither of which I was planning to use, but I always found that request a little weird, like he knew the skate photo aesthetic and wasn't into it. Nate did the interview and when we returned to his car we found it broken into with the thief still rooting through Nate's stuff in the back seat. The guy almost had a heart attack when Nate screamed at him.

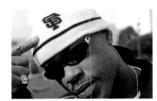

GURU

Taken at the Yerba Buena Gardens in SF. Super personable and down to pose for as many frames as I wanted. This was pretty early on in my SLAP career and I was fairly star struck. I just wanted to listen to him talk, hoping somehow he'd lapse into "Step Into The Arena" accidentally.

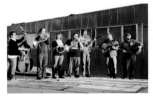

THE MUMLERS

I've known Mumlers singer/guitar–player/song–writer Will Sprott since he was a 13—year—old skater, and hearing him become the driving force behind my favorite contemporary band has been excellent. Spent the day with the band going to spots all around San Jose for weird group shots. Ended up on the roof next to a friend's art studio at sunset and got this one up there.

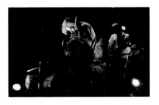

THE DIRTY 3

Dirty 3 shows are eternally the best live band experiences for me. The second time I saw them I interviewed Warren Ellis in the afternoon before the show. At the end of the interview I told him I was about to get married and that "Lullaby For Christie" would be our processional. He took off the sunglasses he'd been wearing the entire interview and told me that was the best compliment he'd ever received. At the show that night he dedicated the encore to me and my "bride to be." That was a highlight. This one was taken during the following tour/album, "Alice Wading."

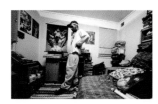

DEL THA FUNKEE HOMOSAPIEN

Taken at his home in Berkeley. He played a bunch of new music for us, showed us around his house, and he and Nate played video games for a long time while I snapped away. It was basically just hanging out with one of the best rhymers ever. For some reason I also remember deciding on the way back home that I was going to propose to my girlfriend/now–wife.

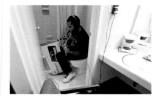

RAY BARBEE

We did a SLAP article where we brought some skater/musicians on the road down the Blues Highway from Chicago to New Orleans, recording music and skating the spots along the way. One of the best trips I ever did for the mag. This is Ray recording on my 4–track in the bathroom of some crappy hotel in Clarksdale, Mississippi just up the street from where the real-life Crossroads are (where Robert Johnson purportedly sold his soul to the devil, but now there's donuts, burgers and discount tires).

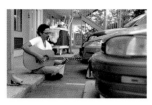

TOMMY GUERRERO — CURB

On the Blues Highway trip. This was taken at the hotel we stayed at just down the road from Graceland, pretty early in the morning. The maids had come by to change the bedding and Tommy picked up his guitar and went out to the curb. I walked out when I heard him playing, and took a moment to take in the scene — here I was on tour with a childhood hero, getting a solo concert from one of my favorite musicians. Hand–written in small letters on the breast pocket area of Tommy's shirt was simply the word "Hendrix."

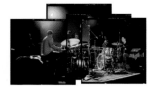

TORTOISE

Tortoise does such a great live show, and there's always so much going on with all the band members moving around the stage and switching around between instruments. It seemed too hard to capture everybody in a single frame so I started shooting different pieces and people and just patched some of the frames together for a little collage. Taken at Bimbos during the tour for "Standards."

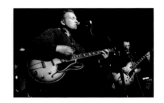

SEA AND CAKE

I remember shooting photos during sound check at Bottom Of The Hill and then interviewing Sam Prekop outside afterwards, but that's about it on this one. Shot while he was touring for his first solo album, and that's a nice album.

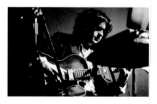

JIM O'ROURKE

Taken at what was then called The Justice League in SF soon after his "Bad Timing" album was out. I went with Marc Johnson and some San Jose friends and remember commenting to MJ after hearing O'Rourke play a cover of John Fahey's "Dry Bones In The Valley" that I could die happily. Possibly the first time I saw anybody use a laptop as an instrument.

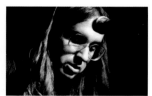

J MASCIS

Amazing acoustic set at the Bottom Of The Hill, way better than his "Martin and Me" album. First time I saw him with those huge Coke can glasses and the last time I saw him with black hair. I had interviewed him on the phone earlier and after the interview was seemingly over and I was about to hang up he said in his deadpan voice, "I can drop in." He just wanted me to know he was legit. Always hated the microphone in the middle of his forehead here.

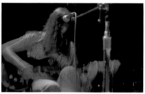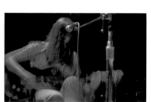

CHAN MARSHALL — STAGE

By this time Chan had gotten pretty famous and was playing bigger venues — this was at the Great American, and it was packed. My strongest memory of this show is her covering The White Stripes' "Dead Leaves And The Dirty Ground" which had just come out. I liked her version more. Anyhow, this one is all about the stage lighting, and I always liked how with the long exposure it looks like you can see the bones in her arm.